IMAGES
of America

NEW CASTLE

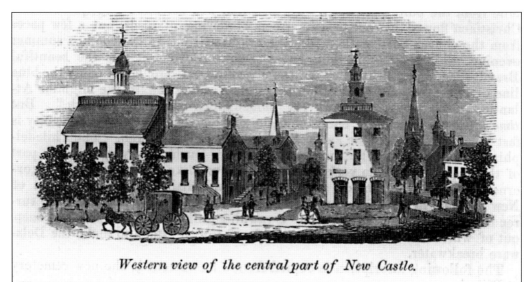

Western view of the central part of New Castle.

The court house is seen on the left, the town hall and market on the right. The spire of the Episcopal Church between the hall and court house; the Presbyterian Church on the right.

ILLUSTRATION, LATE 19TH CENTURY. This line drawing is packed with surprisingly accurate architectural details throughout, as well as a whimsical illustration of period transportation and dress. Only two of the buildings shown here have been torn down. (Courtesy of Don Reese.)

IMAGES
of America

NEW CASTLE

Jim Travers

Published by Arcadia Publishing
Charleston SC, Chicago IL, Portsmouth NH, San Francisco CA

Printed in Great Britain

Library of Congress Catalog Card Number: 2005923383

For all general information contact Arcadia Publishing at:
Telephone 843-853-2070
Fax 843-853-0044
E-mail sales@arcadiapublishing.com
For customer service and orders:
Toll-Free 1-888-313-2665

Visit us on the internet at http://www.arcadiapublishing.com

CONTENTS

ACKNOWLEDGMENTS

Many thanks go to the following: the New Castle Court House staff, especially Cindy Snyder, site manager; the Mayor's Office, for the introduction to Arcadia provided by Mikki DiEmedio; Edward J. Camelli; Dennis Beaumont; Bob Briggs; Cynthia Byham; Gerald Carr (of Newark); Marian Tobin Ellis; the Very Reverend Arthur B. Fiore (of St. Peter the Apostle); C. H. Gebhart IV; Walter Gebhart; Grace D. Hayford; Frances Sheridan Haut; Helen and Harold Hoagland; Mrs. Stanley Klein; William T. Quillen; Don and Connie Reese; Dick Stewart; Ervin Thatcher; H. Richard Travers; Sharon Weaver; and Mr. and Mrs. Fred Wilhelme. My brother, Major N. Travers III, provided photograph and computer assistance, and my wife, Carolyn, offered both constant support and wise editorial advice. Barbara Hall at the Hagley Museum and Library was helpful on many occasions. The New Castle Public Library—Sally Hatton especially—provided space and access to their archives. The Historical Society of Delaware staff, including Constance Cooper, pointed me to the most pertinent items; Winifred Mund, Bruce Dalleo, and others at the New Castle Historical Society gave me a helping hand; and the efficient staff at the Delaware Public Archives in Dover was thankfully available some evenings and weekends. Finally, Jim Salmon, public information officer with the Delaware River and Bay Authority, despite recurring illnesses, provided help whenever he could.

INTRODUCTION

A close look at the "lower 48" United States shows only one with a carefully curved border: Delaware's 12-mile arc, centered at New Castle, was fixed by a survey in 1701.

The original settlement, fought over by Dutch, Swedish, and English governments in the 16th and 17th centuries, has slowly evolved into a remarkable collection of well-preserved houses and peaceful public places. Each generation has planned for expansion and booms that never happened. Today the human scale of our streets, parks, and river vistas is far enough away from the major state and interstate highways that the quiet whispers of Delaware's history can plainly be heard.

William Penn's need for clear access to his "woods" (as the name Pennsylvania is translated to Penn's woods) led to a lease agreement for the Duke of York's lower three counties on the Delaware in 1681. Thus began court sessions, discussions of freedom, and self-government, along with the bustle of a growing river port. Within 20 years, a separate Delaware assembly was established, and it became a training ground for Revolutionary patriots.

The town has always been extremely fortunate thanks to a relationship with the Trustees of the Common. While Penn was familiar with town "commons," documents from Dutch settlers show that New Castle's trustees were founded long before the English arrived. It has become a unique American example of land stewardship and community support. Gifts for needed improvements and grants for fire equipment, trash trucks, and so on have followed the original sharing of 1,036 acres surrounding town for cultivation and use of the woods. Until 1885, the land tract was not broken up, but a special change to their state charter allowed the trustees to use proceeds from sales for other, conservative investments. Land was transferred in 1941 for a military airfield, which is now an airport operated by the Delaware River and Bay Authority. A major postal facility, shopping centers, restaurants, and a regional distribution point for Amazon.com occupy much of the remaining property.

The leadership of early Colonial governors like John Evans, and the disastrous heavy hand of Charles Gookin, gave New Castilians the experience of political ups and downs through the early 18th century. During the 1730s, the laws of Delaware were in need of codification, and in 1742, Benjamin Franklin printed the results generated by the New Castle legislature. Included were government procedures for conduct of courts, recording of deeds, and overseeing the poor. Statutes for punishment of crimes included fines, lashing, standing in the pillory, and death, and they generally followed English examples.

Parliament's mid-century acts attempting to constrict freedom and raise larger amounts of money prompted Delaware's separation from the crown in June 1776. Twenty days later, the Declaration

of Independence was published in Philadelphia, expressing overall Colonial dissatisfaction with George III and English rule.

The "Delaware State" was established here in September 1776, but the seemingly long journey to New Castle by delegates from downstate, and General Howe's occupation of Wilmington, caused the legislature to permanently move to Dover in May 1777.

A great fire on April 23, 1824, devastated the Strand, including the home of George Read, a signer of the Declaration, and many others, resulting in the then-exorbitant loss of over $100,000 in personal property.

New Castle and Frenchtown Railroad's opening in 1831 helped bring more commerce and people through town, but 1881 marks the movement of the courts and county seat away to Wilmington. Begun in 1897, local electric trolley service helped keep some activity here, but a gradual decline was inevitable in the early 20th century, as industrial plants producing cast iron and steel were shuttered during corporate mergers. The inspiring story of Bellanca Aircraft design and production just outside town from the late 1920s to mid-1950s will be retold soon in a planned transportation museum in one of the old hangars.

From 1925 to 1951, crossing the Delaware River was only possible by ferry, and motorists waited hours on quaint streets to board at the Delaware Street Wharf and after 1929, at the end of Chestnut Street. Ferry traffic decreased immediately following the opening of the first Delaware Memorial Bridge. Population and commercial growth along the East Coast forced construction of a second span, completed in 1968.

Now surrounded by 10- to 40-year-old housing tracts and innumerable office and industrial parks, New Castle depends on the steady support of the Trustees of the Common, Municipal Services Commission, property taxes, licenses, fees, and building permits to stay alive. Travel writers occasionally discover our eclectic mix of preserved buildings and help those directly involved in tourism.

Despite many efforts to change, destroy, or exploit the charms of a unique American town, we can be thankful that over the years, most residents have been savvy enough to hold on to what they have.

One

KEEPING HISTORY ALIVE

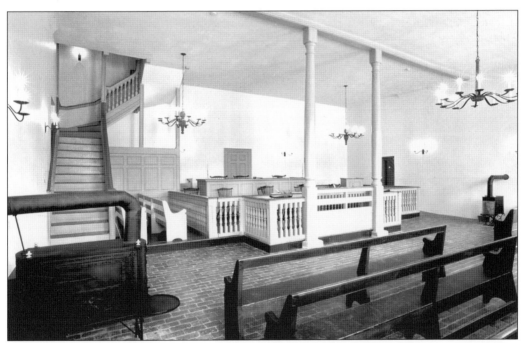

NEW CASTLE COURT HOUSE INTERIOR, 1732. The original 30-foot-by-30-foot, *c.* 1689 building was destroyed by fire in 1730. This room was the meeting place of Colonial and state assemblies, as well as all jurisdictions of Delaware courts, including federal courts. Norman Rockwell, Shirley Temple, and others visited a tea room here in the late 1940s. (Photograph by Gerald Carr.)

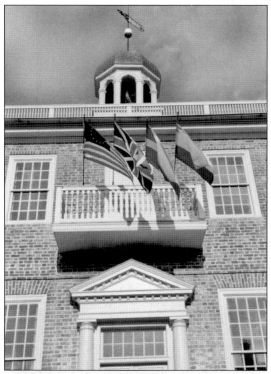

FLAGS OF FOUR NATIONS. Holland, Sweden, England, and the United Sates have laid claim to Delaware and its first important town. Delawareans are most proud of the actions of the local courts and assemblies that followed—then rebelled against—English rule.

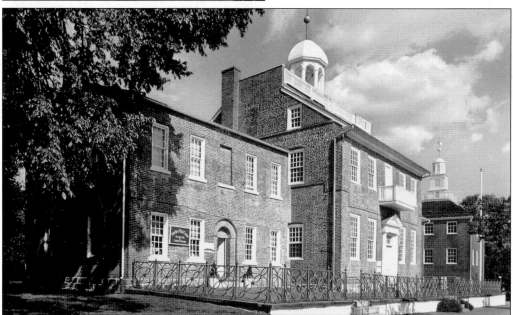

CENTER OF DELAWARE'S ARC. Commissioners of William Penn and George Calvert agreed on February 1, 1732, to measure the 12-mile arc of Delaware's border from this spire. After a 1771 fire, the roofline and cupola were changed to a Georgian style, as seen here. The west wing, to the left, is a fireproof replacement for a smaller 1765 wing, which cost about £220 and was used for offices and schoolrooms. The upper meeting rooms of the central portion have been used by numerous religious denominations. (Photograph by Gerald Carr.)

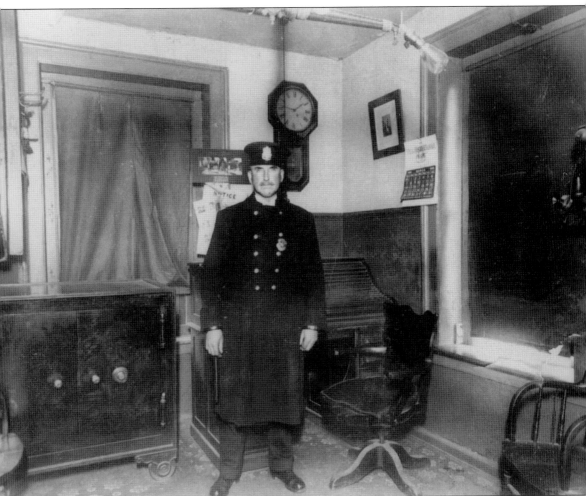

CHIEF OF POLICE, 1915. Matthew Tobin stands in the east wing of the courthouse, where the city police had their office. The tradition of maintaining the peace at New Castle stretches back to the appointment of Edmund Cantwell as high sheriff in 1672. The county jail and sheriff's house, adjacent to the courthouse on the Green, were active until the late 19th century. Note the large safe, roll-top desk, and telephone. While the police force consisted of only two officers then, now it includes a staff of 15 patrolmen and detectives, plus a full-time chief, located in a new building just outside of town. (Courtesy of New Castle Court House Museum.)

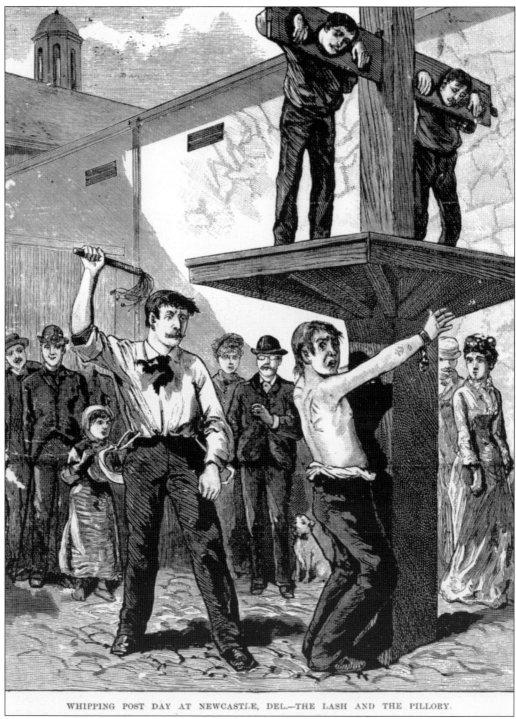

WHIPPING POST DAY AT NEWCASTLE, DEL.—THE LASH AND THE PILLORY.

NINETEENTH-CENTURY PUNISHMENT. In a courtyard behind the courthouse, petty criminals stood in the stocks or received lashes with curious onlookers present. Techniques from the 17th century for dealing with many minor offenses persisted in Delaware until the mid-20th century, long after they had been abandoned in most other states. (Courtesy of Grace D. Hayford.)

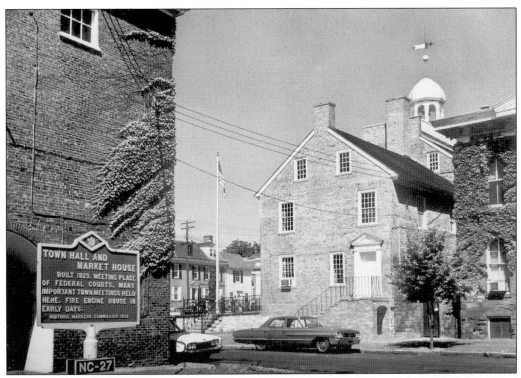

COURTHOUSE NEIGHBORS. The original marketplace behind the town hall (above) bustled with activity through the 18th and 19th centuries, whether or not state and county courts were in session across the street. Originally designed with two stories, a third was added for Mason meetings. One of New Castle's few stone buildings, the Sheriff's House (below), designed in the 1850s by Samuel Sloan, has since been used by city police and as a mid-20th-century men's club, and it has been incorporated in future restoration plans by Delaware State Museums. (Above courtesy of New Castle Court House Museum, below photograph by Gerald Carr.)

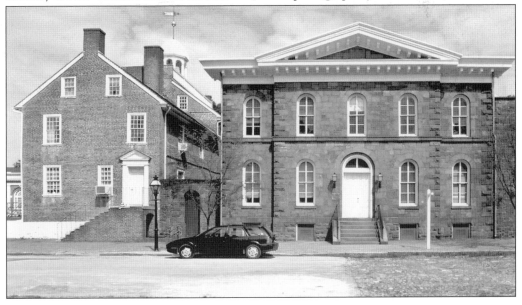

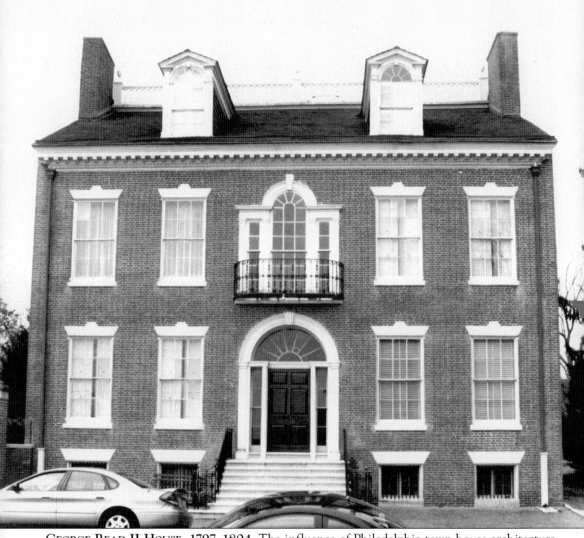

GEORGE READ II HOUSE, 1797–1804. The influence of Philadelphia town house architecture is reflected here in Delaware in an outstanding example of the American house museum. The Historical Society of Delaware received the house from Mrs. Philip D. Laird in 1975. The meticulous restoration that ended in 1985, reflecting research of numerous family documents, presents the mansion's 22 rooms as the Reads would have used them. Original, unusual paint colors and wallpaper were discovered under later decorations. Fine finished mahogany was originally painted over for mantels, and then Philadelphia plasterer Robert Wellford added delicate ornaments in the Adamesque style. After purchasing the property in 1846, William Couper developed the extensive gardens under the direction of Robert Buist of Philadelphia. A late-1920s, pseudo-German taproom installed by the Lairds still welcomes visitors in the basement.

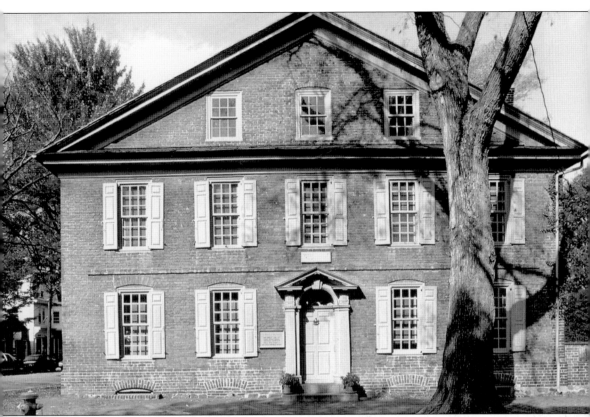

AMSTEL HOUSE, C. 1738. This handsome, five-bay Georgian structure houses the collection, offices, and primary museum of the New Castle Historical Society. Built by John Finney, the house was the site of the marriage of Ann van Dyke and Kensey Johns Jr., with George Washington probably in attendance, on April 30, 1784. The detailed paneling in the first-floor parlor was studied during the Depression and featured in the earlier White Pine Series of architecture monographs, as well as in books by George Fletcher Bennett and others. The small back kitchen area probably dates to the late 17th century. (Photograph by Gerald Carr.)

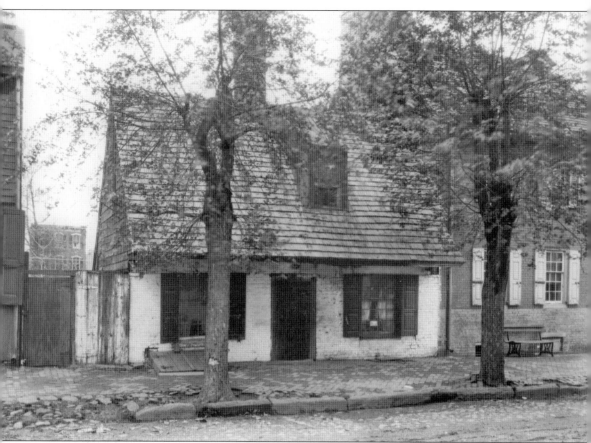

THIRD STREET, MID-1930S. Town records list this house in 1704, though legend has its erection much earlier. The original impetus to convert it to a museum was had by the Delaware Society for the Preservation of Antiquities. In 1939, the house on the left was moved and became the center section of the house on the right. The empty space was converted to a small formal garden. Note the small, off-center dormer window and the painted white walls and compare to the photograph opposite. All rooms downstairs are furnished with period Dutch implements, which may have been used by its early owners. (Courtesy of Delaware Public Archives, Dover.)

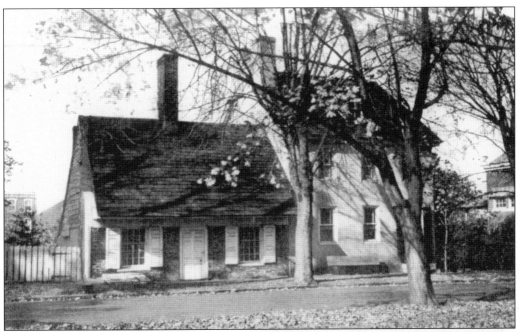

OLD DUTCH HOUSE MUSEUM. By cleaning off the paint, removing the dormer in the attic, and adding white shutters, the historical society created a well-loved landmark near the Green. In 1674, the lot was owned by a former Dutch governor, Jean Paul Jacquet, and the owners remained Dutch into the 18th century. (Courtesy of Grace D. Hayford.)

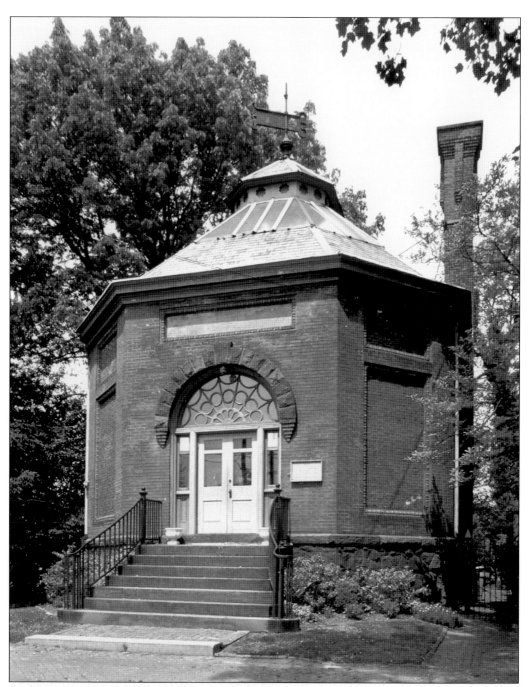

OLD LIBRARY MUSEUM, 1892. The original library company, founded in 1812, used a classroom in the academy until this building was finished. William Camac, architect with the Philadelphia firm of Furness, Evans, and Company, produced the plans. The eclectic use of brick, stone, and bright polychrome trim is typical of their firm's strong designs, and the open stack area is well-lit by skylights. In 1965, the library moved to a new building on Delaware Street. A sculptor used the space for both living and a studio until 1980, when the trustees renovated the building for use by the New Castle Historical Society. (Photograph by Gerald Carr.)

Two

VISUAL LEGACY
CAPTURED AND
ALMOST LOST

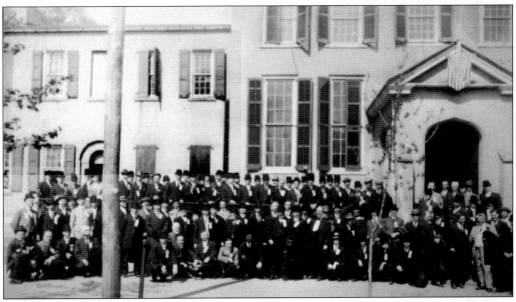

EARLY-20TH-CENTURY VISITORS. This group of unknown men, many with ribbons and almost all wearing dark, formal clothes and hats, stands outside the New Castle Court House between 1910 and 1914. The wooden American banner on the portico was recovered and analyzed for an exact identification, but the lettering has almost disappeared. (Courtesy of New Castle Court House Museum.)

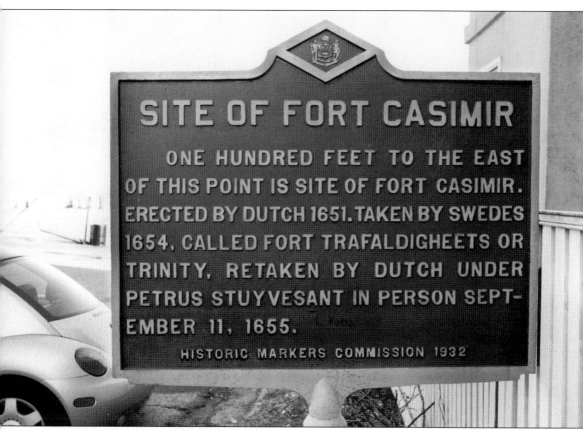

SITE OF FORT CASIMIR

ONE HUNDRED FEET TO THE EAST OF THIS POINT IS SITE OF FORT CASIMIR. ERECTED BY DUTCH 1651. TAKEN BY SWEDES 1654, CALLED FORT TRAFALDIGHEETS OR TRINITY, RETAKEN BY DUTCH UNDER PETRUS STUYVESANT IN PERSON SEPTEMBER 11, 1655.

HISTORIC MARKERS COMMISSION 1932

ORIGINAL MARKER, 1932. The Depression-era push by many states to encourage "history tours" resulted in 13 markers in or near New Castle, six of which are missing. Though originally silver-gray with black letters, official Delaware blue and gold are now used. This oldest area of settlement has seen fortifications, a tannery, a cooper shop, pastures, cemeteries, and a boatyard. Archaeological research in the late 1980s uncovered delftware, cannonballs, tin tiles, and a tombstone. The second Delaware River Ferry to New Jersey, which ran from 1929 to 1951, had its terminus here. (Photograph by Bob Briggs.)

Van Leuvenigh House, 1732. Trains heading for Frenchtown departed from here starting in February 1832. The tracks can be seen in the foreground. At the far right on the Strand are the 1845 Farmer's Bank Building and a home occupied by George Read II and Gunning Bedford. This area is now part of Battery Park. (Courtesy of Delaware Public Archives, Dover.)

IMMANUEL PARISH (THOMAS) HOUSE. Originally both a hotel and a dwelling, this 1801 structure at the corner of the Strand is the product of Peter Crowding, who worked on George Read II's house, visible on the far left. With strong, fan-lighted entrances on two streets and four stories, it is slightly out of scale with its neighbors. A descendant of original owner Charles Thomas gave it to Immanuel Episcopal Church in 1891. The early-20th-century addition, designed by Lausat Rogers, includes classrooms and an auditorium. (Courtesy of New Castle Court House Museum.)

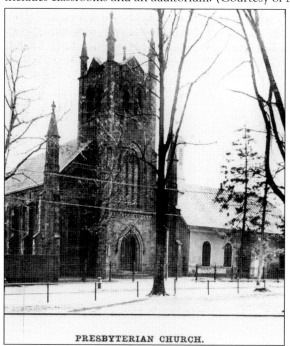

PRESBYTERIAN CHURCH.

NEW PRESBYTERIAN CHURCH, 1854. This Gothic-Revival hulk was built close to the second, brick Presbyterian Church (built in 1707) but has since been demolished. The congregation traces its lineage to the town founders, who first held Dutch Reformed services at Fort Casimir, then in a small structure on the Strand. A schoolmaster and a minister arrived in 1657, and the first English services were held by John Wilson in 1703. (Courtesy of New Castle Court House Museum.)

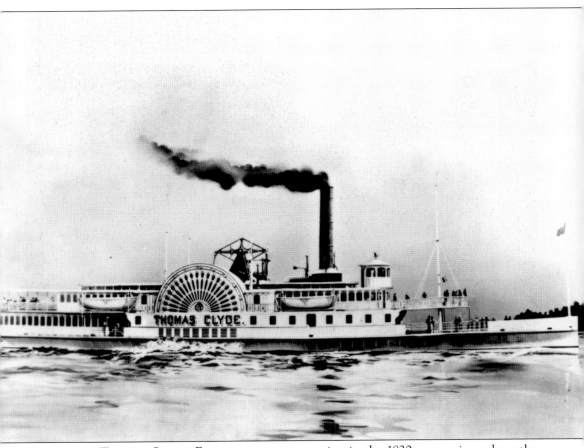

STEAMBOAT *THOMAS CLYDE*. For over a century starting in the 1820s, excursions along the Delaware River were extremely popular. After the Chesapeake and Delaware Canal opened in 1829, at least two lines competed to provide fast service to Baltimore. Maj. Philip Reybold built his ships locally at Wilmington shipyards. The *Clyde* and her sister ship, the *Major Reybold*, were primarily used to transport peaches from Delaware City to Philadelphia but traveled downriver for picnics as far as Bombay Hook and docked frequently at the Delaware Street Wharf. (Courtesy of New Castle Historical Society.)

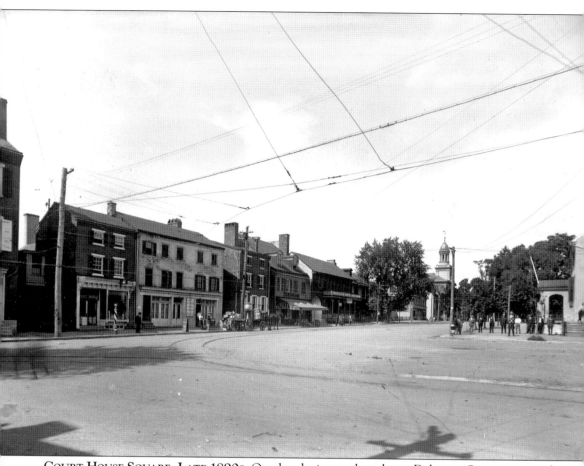

COURT HOUSE SQUARE, LATE 1890S. Overhead wires and tracks on Delaware Street were used after 1897 by the first electric trolley service. Townspeople still used buggies and stared at the rare photographer. At the right, the cupola on the Masonic Opera House is still in place, and the portico on the front of the courthouse is still visible. Other than the adjacent, old front awning and porch in the center, every building in this photograph still stands and is easily recognizable today. (Courtesy of Historical Society of Delaware.)

MARKET STREET FACING HARMONY, C. 1900. The Sheriff's House, to the left, is still attached to the jail, which seems to adjoin the arsenal, with its original cupola barely visible. To the right, the marketplace shed (see page 13) has not yet been torn down. (Courtesy of New Castle Historical Society.)

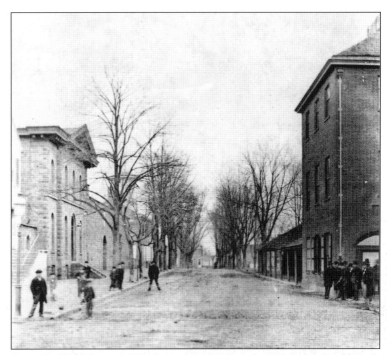

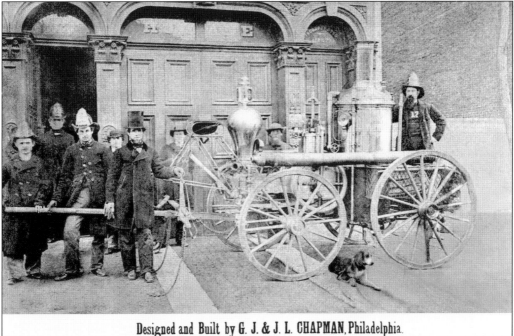

Designed and Built by G. J. & J. L. CHAPMAN, Philadelphia.

HUMANE STEAM PUMPER, 1885. The men in fire hats are members of New Castle's Penn Fire Company (founded in 1823), ready to receive delivery of their gift from the trustees at the Chapman works in Philadelphia. Starting with the Union Company in 1796, many volunteers have battled blazes in town. The Lenape (1887) and Good Will Fire (1907) Companies followed, all committed to providing fire and ambulance service and marine rescues. Some current members have been trained in specialty rescue techniques. (Courtesy of Ervin Thatcher.)

AULL'S ROW, C. 1801. John Aull and his brother, William, both recent immigrants from Ireland, built these town houses on Second Street near the back gardens of the George Read II House. While each house is slightly different, they all originally incorporated vertical tongue-and-groove trim inside and a heavy, Victorian cornice treatment outside. Today the windows of the early-20th-century bakery, seen here, hold displays of recent art work. (Courtesy of Historical Society of Delaware.)

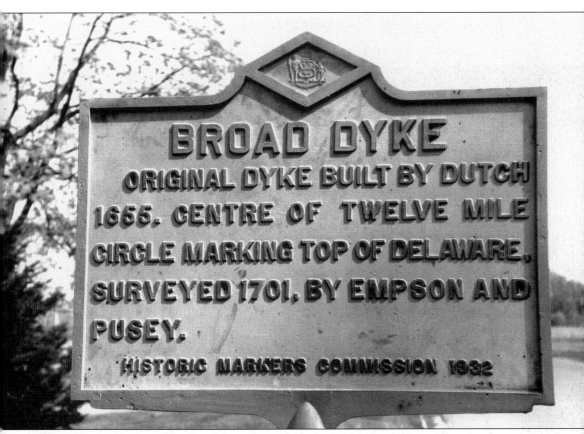

BROAD DYKE MARKER. The Dutch brought with them vast experience pumping water to create more usable land. Within four years of the construction of Fort Casimir (less than half a mile from this marker), they needed to create safe, dry access to their surrounding fields and settlements farther upriver. Research for the 1932 text shown had not revealed that the center of Delaware's 12-mile arc officially is the New Castle Court House cupola, not quite a half mile away.

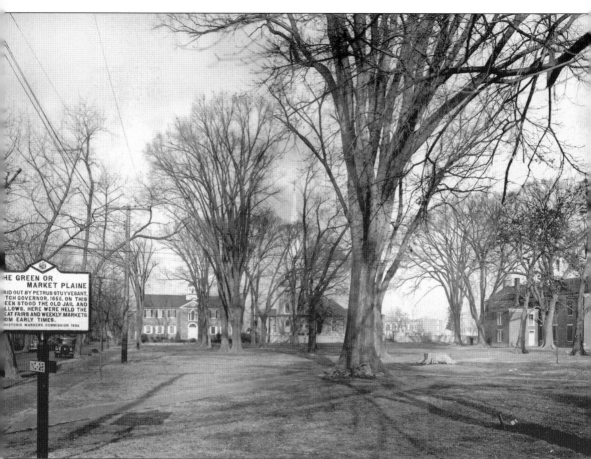

THE GREEN, C. 1950. From left to right are the Academy (built in 1798), Immanuel Episcopal Church (1703), and the Arsenal (1809), facing Harmony from Delaware Street, near the courthouse. Behind the Academy is a secret garden reached only by passing through the building. Largely hidden in this view, the steeple of Immanuel is a nighttime beacon, and its change bells and clock resonate throughout the town. In response to British threats, a one-story arsenal was erected for storing ammunition and was used until the Mexican-American War in 1846. After the addition of a second story, it was used as a school until 1931, when William Penn School opened. (Courtesy of Delaware Public Archives, Dover.)

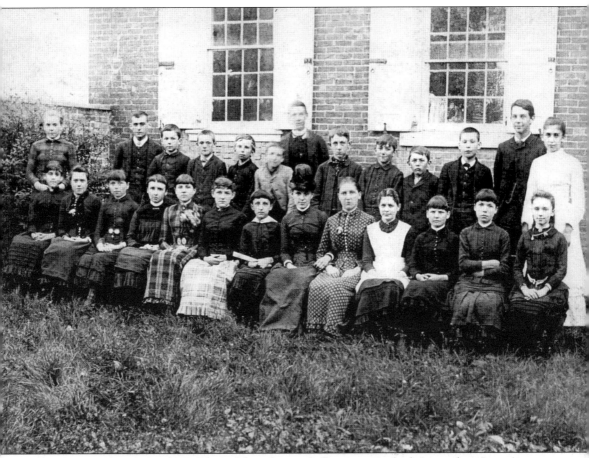

NEW CASTLE SCHOOL, 1889. These 25 students of all ages sit with their teacher, Jane Anne Moor (center, wearing the hat). No one else can be identified. The photograph was taken in the confines of the small secret garden directly behind the Academy. Everyone seems to have gotten dressed up for the photographer. (Courtesy of Cynthia Byham.)

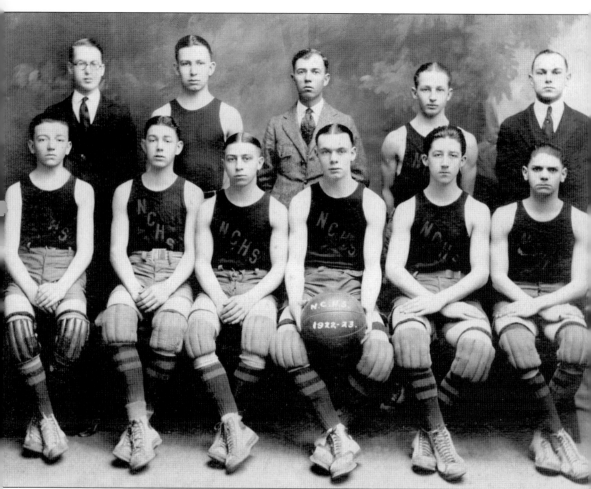

N.C.H.S. Men's Basketball Team, 1922–1923. While someone has written some of the nicknames of these boys around the perimeter of the photo, it is impossible to identify them today. The two suited men at the corners on the back row are the coaches. Notice the different styles of hand-folding on the left and right of "Sam," who is holding the ball. (Courtesy of Grace D. Hayford.)

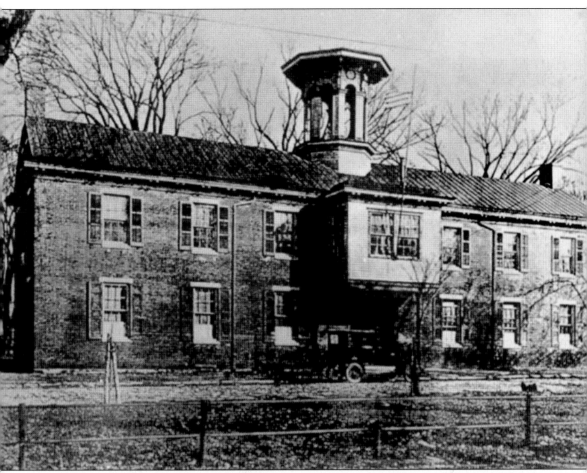

THE ARSENAL BUILDING, EARLY 1920S. This photograph was probably not taken on a weekday, although few students or teachers would have driven to school. Notice the partial blocking of the first-floor windows and the odd rectangular second-story bay, removed long ago. Built just before the War of 1812, the building was utilized as a garrison while Fort Delaware was rebuilt following a fire in 1831. The cupola seen here has been replaced with one similar to that on the courthouse. (Courtesy of Delaware Public Archives, Dover.)

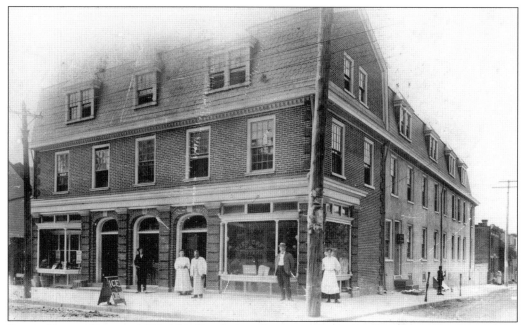

DAVID FINNEY INN, C. 1683. The Dutch issued a patent for the land in the 1650s. Wings have been added and the front windows and doors have been modified since the days of David Finney, an attorney and militia officer. The mansard roof was added in 1903. Former occupants include the water office, a hotel and taverns, drug and cigar stores, and now, a law office. (Courtesy of New Castle Historical Society.)

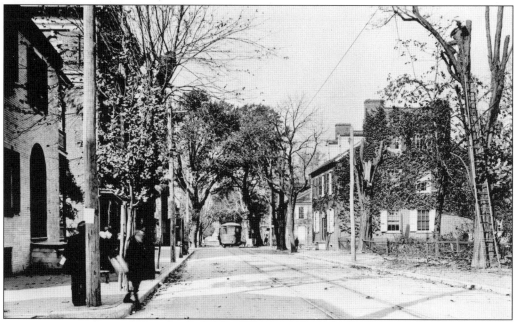

DELAWARE STREET, C. 1910. Electric trolley service to Wilmington started in 1897 and eventually extended south past Deemer's Beach to Delaware City. The old trolley barn just north of town is used to store equipment, machinery, and trucks and houses the building inspector's office. (Courtesy of Historical Society of Delaware.)

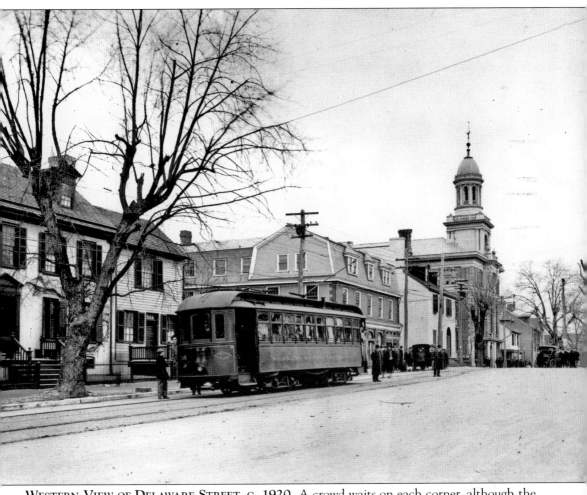

WESTERN VIEW OF DELAWARE STREET, C. 1920. A crowd waits on each corner, although the trolley has just gone by. The tall building at the right is the Opera House, completed by St. John's Masonic Lodge in 1880 and which now houses a rare book dealer. The cupola was removed after a powerful storm in the 1940s. The David Finney Inn is behind the trolley car. (Courtesy of Historical Society of Delaware.)

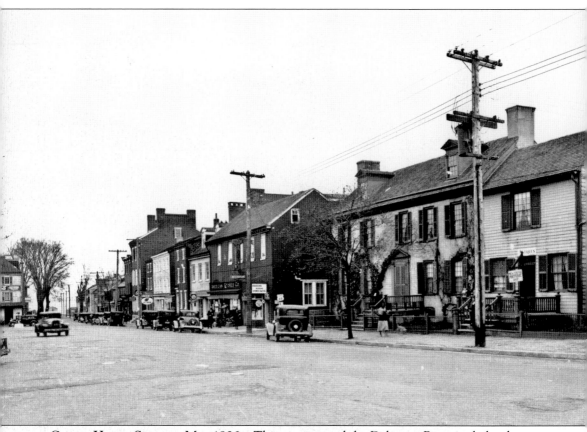

COURT HOUSE SQUARE, MID-1920S. This view toward the Delaware River includes these same buildings today, with changes only to the signs and autos. At the center, the Gilpin House, formerly a hotel, has been restored by Wilmington Trust Company, Delaware's largest locally owned bank, since its use here as a supermarket. The Booth House, at the right, was first occupied by the second Presbyterian minister in the 1740s. Judge James Booth conducted trials in the 19th century across the street at the courthouse, often leaving jurors amid their evening discussions to go to bed. The gray stucco, porches, and shutters have all since been removed. (Courtesy of Historical Society of Delaware.)

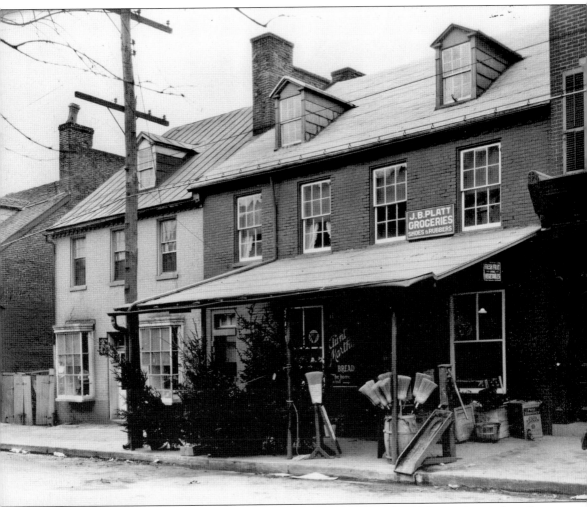

120 AND 122 DELAWARE STREET. These buildings trace back to the 18th century, with early kitchens and small rooms. J. B. Platt Groceries was both a dwelling and a unique, full-service location with curbside water pump, groceries, hardware, shoes, and a local boy to make deliveries until the 1950s. Edward Platt's constantly fluttering whistle will always stick in his many patrons' memories. (Courtesy of Historical Society of Delaware.)

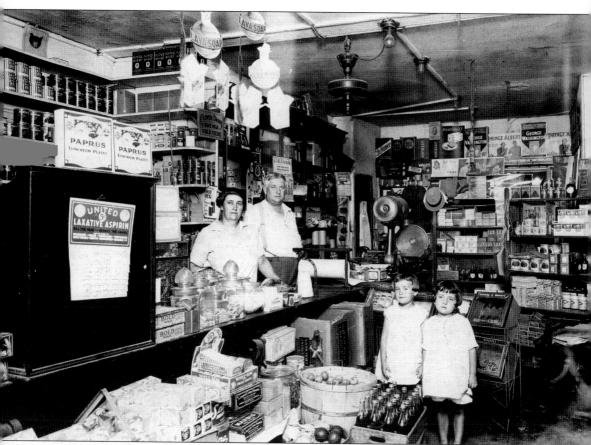

INTERIOR OF JOHN F. Z. CLAYTON STORE, C. 1928. At the counter stand Elizabeth Proud Clayton and her husband, John, the proprietor. Jeanette Emma Clayton (left), their daughter, is standing next to neighbor Betty Jane White, both about five years old. A magnifying glass reveals a huge variety of goods in this half of the store, including fresh fruit, soda, crackers, candy, canned fruit, coffee, soap, tobacco, gum, bleach, cookies, and much more. The sign above Mrs. Clayton's head reads "Clover Dairy Safe Milk Sold Here." (Courtesy of Walter Gebhart.)

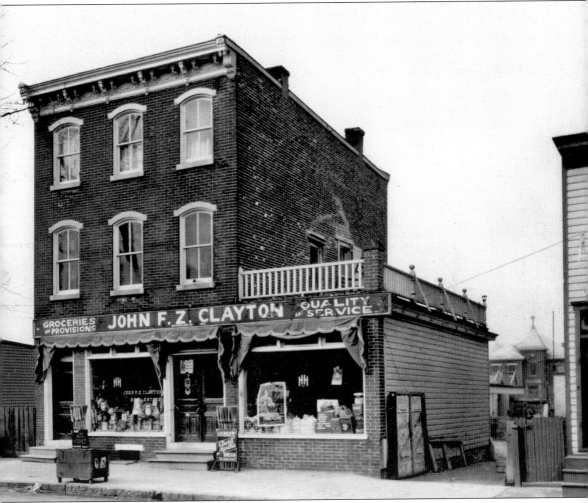

HOME AND STORE OF JOHN F. Z. CLAYTON. A general store was established in 1902 in this building, which was built in the late 1850s. The property backed up to St. Peter the Apostle catholic church, whose parochial school building can be seen to the right in the distance. A rocking chair is visible on the deck above the right-hand side of the store. Lettering in the left-hand window indicates that Mr. Clayton also sold real estate. In the early 1980s, the building was torn down for the expansion of the church's adjacent graveyard, and the bricks were recycled. (Courtesy of Historical Society of Delaware.)

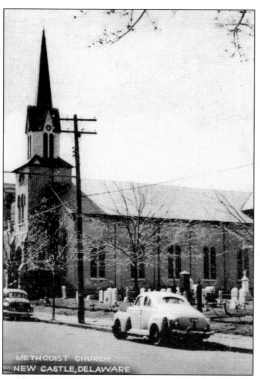

UNITED METHODIST CHURCH, 1863. The roots of American Methodism can be traced to George Whitefield's arrival at Lewes, Delaware, in 1739. His enthusiastic preaching on the Delmarva Peninsula for decades created followers who purchased land in 1820 then erected a small chapel here. The old foundations remain in the graveyard. In 1863, the present church was completed, followed by additions for Sunday school in 1876 and a fellowship hall in 1956. (Courtesy of Don Reese.)

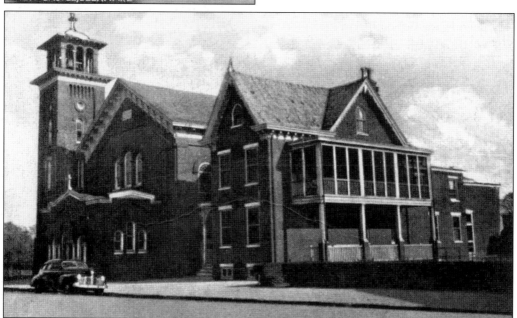

ST. PETER THE APOSTLE PARISH AND RECTORY. Catholics have been worshipping near this corner of Fifth and Harmony Streets for over 200 years. A small wooden chapel from 1807 was replaced within 30 years, and this larger sanctuary was constructed during the 1870s. Expansion continued, with the addition of the belfry in 1896 and the dedication of the entrance and staircase in 1911. The two-story porch on the rectory was enclosed in the late 1950s. (Courtesy of Grace D. Hayford.)

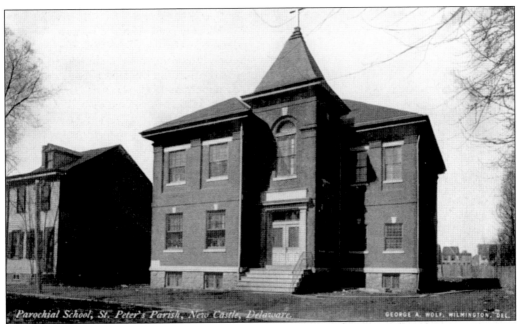

Parochial School, St. Peter's Parish, New Castle, Delaware. GEORGE A. WOLF, WILMINGTON, DEL.

PAROCHIAL SCHOOL, ST. PETER PARISH, 1906. This school was staffed by the Sisters of St. Francis for over 80 years. The first nuns came from Philadelphia, and a convent was soon erected at Fifth and Delaware Streets; it was replaced in 1960. The elementary school was expanded to 9th and 10th grades in 1920, with a complete high-school curriculum taught from 1931 to 1970. The building was demolished in 1965, and an adjacent school building was used until 1970. The original space is now a parking lot. (Courtesy of Don Reese.)

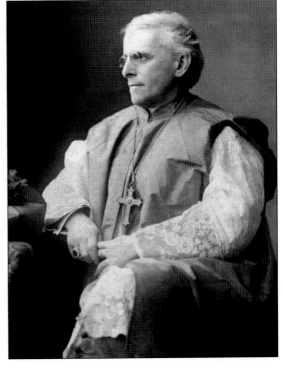

BISHOP BENJAMIN J. KEILEY. Father Patrick Kenney, Father John Rosseter, and Father Charles Whelan, who lived at St. Mary of the Assumption, Coffee Run, conducted services at New Castle until about 1830 when the first building for St. Peter the Apostle was completed. The long line of pastors includes Reverend Keiley, at right, who resided at St. Peter's from 1873 to 1880 and later became Bishop of Savannah, Georgia. (Courtesy of St. Peter the Apostle.)

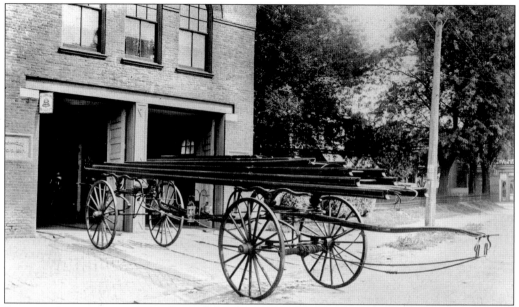

LADDER APPARATUS, 1865. The firehouse erected in 1882 on South Street has held dozens of pieces of equipment. This horse-drawn ladder truck from 1865 helped battle blazes in the massive buildings constructed during the Victorian era. Before then, the Read House on the Strand was the largest building. The Lenape and Good Will Fire Companies both used this building. (Courtesy of Delaware Public Archives, Dover.)

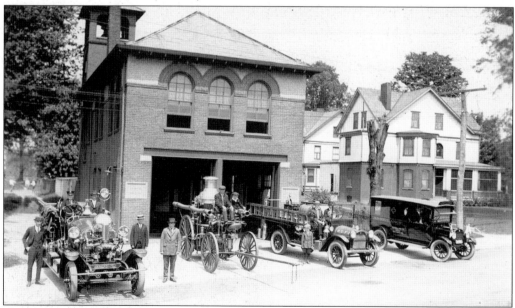

EQUIPMENT LINE-UP, 1924. The Good Will Fire Company has held onto only one of these vintage engines—the 1919 Ahrens-Fox at left. They are the original owners and had a complete, two-year restoration done around 1990 by Andy Swift of Maine. This 1924 photograph includes from left to right "Pete" Dorris, John Walls, and Dick McCasson at the Fox, as well as Francis Reynolds and "Andy" Lenoir at the Reo Engine (third from left). The boys and the other men are unidentified. (Courtesy of Mrs. Harold Hoagland.)

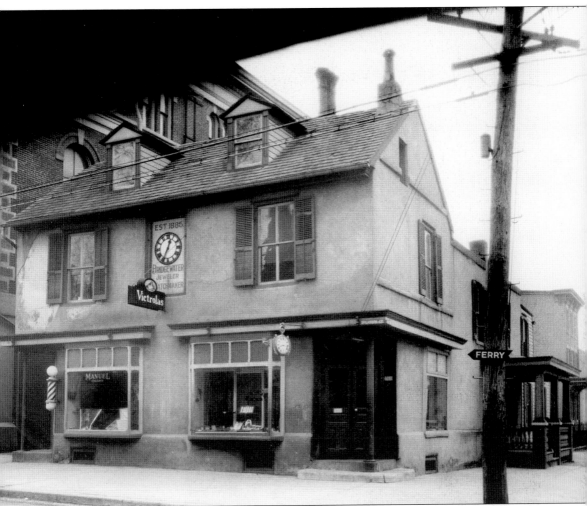

BRIDGEWATER JEWELERS. A barbershop occupied the left-hand side of the building before the family expanded in that space in 1949. Customers entering the right-side porch could see new Victrola machines and listen to the latest records. Notice the common local practice of using "corner-cut entrances," rarely seen outside of Delaware. Since the sign points down Delaware Street to the ferry, the photograph must have been taken between 1925 and 1929. The family still runs the business. (Courtesy of Historical Society of Delaware.)

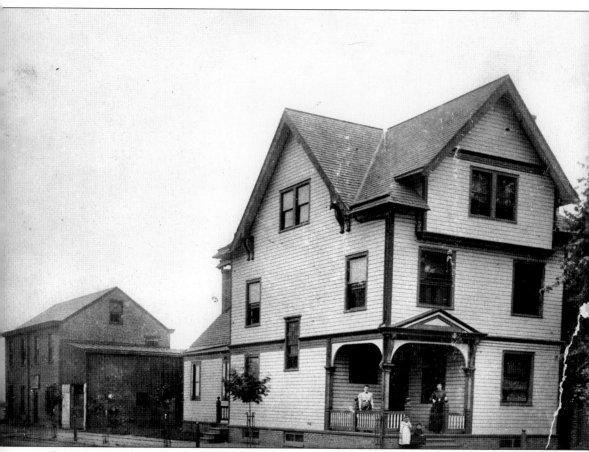

GEBHART FUNERAL HOME, 1885. The oldest continuously operating funeral establishment in New Castle County began here, at 531 Delaware Street, in 1885. Founded by Charles H. Clewell, the business was sold to Chandler H. Gebhart in 1919, and his great-grandson operates at the same location today. Many early funeral "homes" fit the category of multi-use buildings, with two generations of the family being raised above the first-floor public viewing rooms. (Courtesy of Chandler H. Gebhart IV.)

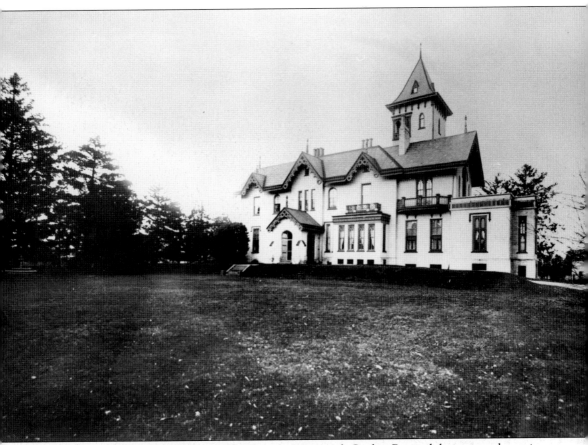

HOME OF DR. ALLEN V. LESLEY, 1855. This asymmetrical, Gothic-Revival design stands out in New Castle. Architects Thomas and James Dixon of Baltimore created a showplace for a surgeon moving from Philadelphia. Total living space is about 13,000 square feet. It includes original chandeliers, marble mantels, massive pocket doors, and 13-foot ceilings. Lesley eventually served as a member of the Trustees of the Common. "New" by New Castle standards, the house is listed on the National Register of Historic Places. (Courtesy of Delaware Public Archives, Dover.)

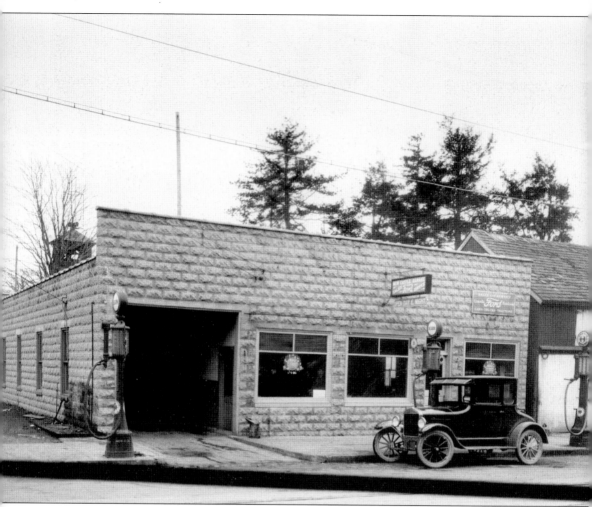

NEW CASTLE GARAGE, 1920s. Brothers Nelson C. and Robert J. Quillen sold gas, oil, and popular Ford (and the occasional Lincoln) automobiles out of this utilitarian building on Sixth Street for 30 years. When the dealership moved the showroom and service bays out of town in the mid-1960s, collision repairs were made here. The three American-made auto dealers (Quillen Ford, Travers Chevrolet, and Gambacorta Chrysler-Plymouth) maintained a friendly rivalry for years. A construction company now occupies the site. (Courtesy of Historical Society of Delaware.)

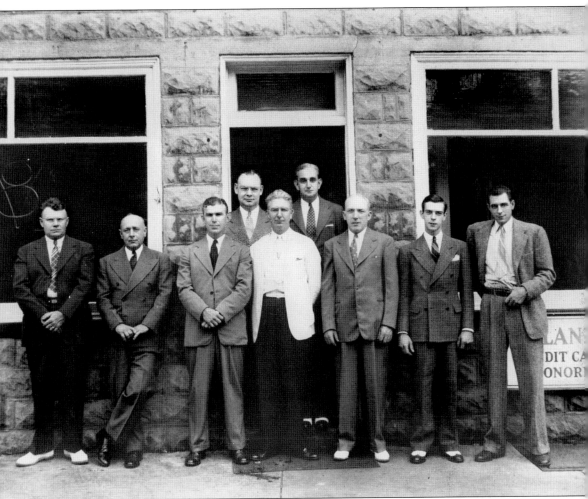

STAFF OF QUILLEN BROTHERS AUTO SALES, C. 1948. Decked out in a variety of formal business attire are, from left to right, (first row) Bert Howell, Dodge Walton, Stanley Klein, Nelson C. Quillen, James Carlin, Ira Sharpley, and Bud Cannon; (second row) Sam McNitt and Robert J. Quillen. The window sign at left promotes the Ford V-8 engine. (Courtesy of William T. Quillen.)

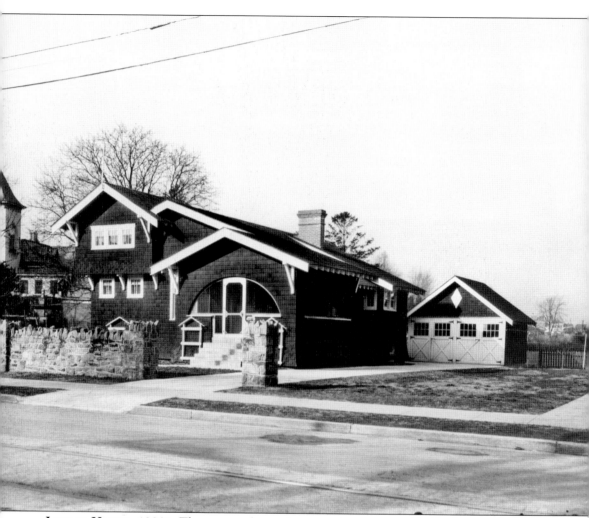

LUOMA HOUSE, 1920s. There are only two houses using recognizable Craftsman elements in New Castle, and this is the earliest. The strong massing of shapes, differing elevations, heavy supported eaves, and a variety of window sizes are all combined here. This lot is part of the subdivided Lesley property (see page 43) broken up by Seldon Deemer in the early 20th century. It is now being restored. (Courtesy Historical Society of Delaware.)

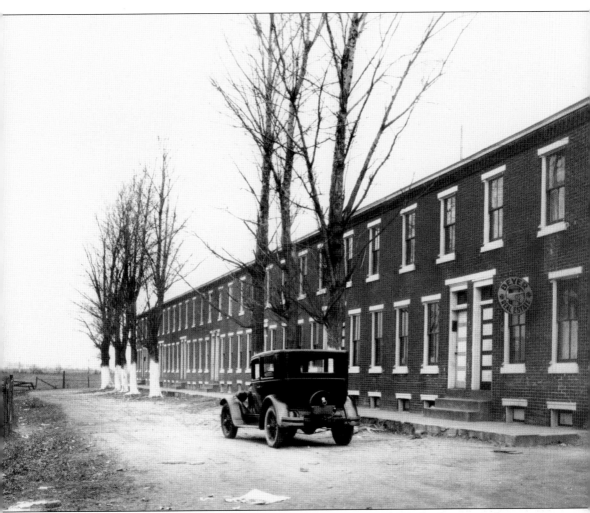

Worker Housing, Dobbinsville, 1930s. Steel, iron, aircraft, and other manufacturing facilities created a need for solid, inexpensive dwellings in and around New Castle. These simple but elegant rows of town houses on Clymer Street are a little less than a mile south of town but near a quiet bend in the river. (Courtesy of Historical Society of Delaware.)

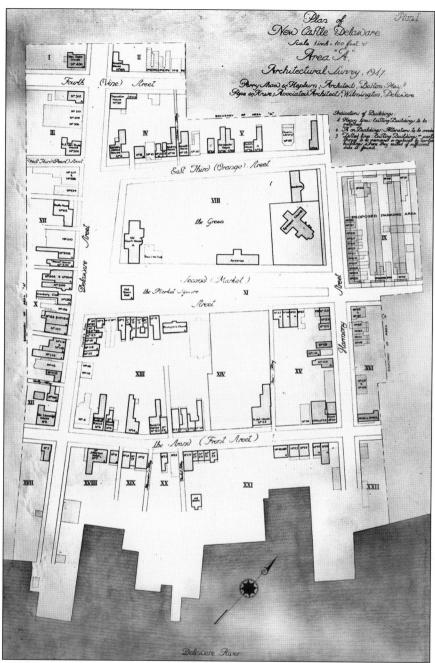

ARCHITECTURAL SURVEY, AREA "A," 1947. Inspired by Williamsburg's success, Daniel Moore Bates planned to eliminate many structures and turn New Castle into a 1830s outdoor museum. Those slated for removal are indicated here by dotted lines. On the right, only one building on the north side of Harmony Street between the Strand and Second Street would still be standing; the next block up would have been leveled for a parking lot. Also slated for destruction were the Old Library, the Opera House, the Sheriff's House, the David Finney Inn, and the Old Farmer's Bank, a total of over 50. Fortunately, funds for the project could never be raised. (Courtesy of Historical Society of Delaware.)

Three

FLYING BY AND
PASSING THROUGH

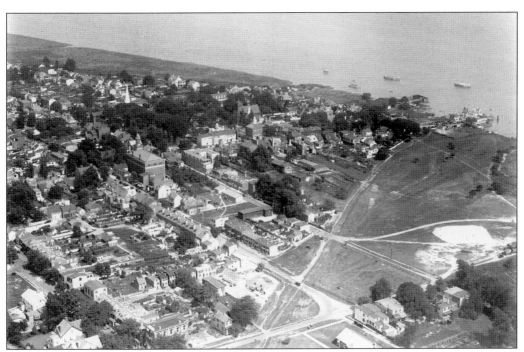

SEPTEMBER 2, 1925. This view from the southwest shows the path of the long-abandoned New Castle and Frenchtown Railroad tracks leading from the river. They are now completely covered over in Battery Park. The crowd waiting to board the ferry is visible at far right, and the New Castle Court House is still clad in off-white stucco. Considering the extreme challenges of still photography in a moving aircraft, the clarity of the images from this old aerial sequence is remarkable. (Courtesy of Hagley Museum and Library.)

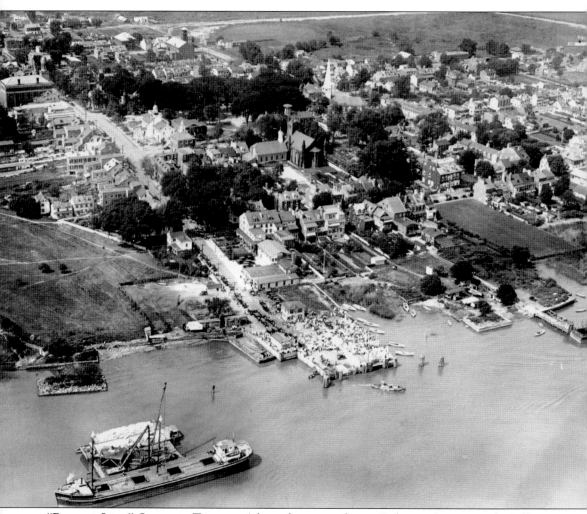

"Pioneer Line" Opens to Traffic. A line of cars stretches up Delaware Street past the Jefferson House. On busy weekends for almost 30 years, the line frequently stretched two miles west to U.S. Highway 13, the modern road given to the state in 1924 by T. Coleman du Pont. In the middle, the Presbyterian church built in the Gothic style still stands. The Read House, covered in ivy, has an uninterrupted view of the river at right. (Courtesy of Hagley Museum and Library.)

The New Castle-Pennsville Ferries, Inc., was organized to meet an urgent demand for a short ferry service across the Delaware River between New Castle and the New Jersey shore.

For years local business men in New Castle had endeavored to interest river transportation companies, particularly the Wilson Line, in the project. All appeals to them for the establishment of a ferry at this point fell upon deaf ears, the Wilson Line officials declaring that their ferry between Wilmington, Delaware, and Pennsgrove, New Jersey, met every need.

After repeated attempts to get these officials to reconsider their decision and establish a line at New Castle had met with failure, residents of Delaware and New Jersey joined together and formed this new ferry company.

This company—the Pioneer Line in this section—constructed piers on both sides of the river, the head-on dock at Pennsville being a model of its kind, and established a line of boats running between New Castle, Delaware, and Pennsville, New Jersey. This Line was put in service on Labor Day, 1925, and immediately found favor with automobilists traveling from the South enroute to places in New Jersey, particularly the Atlantic Seacoast. As soon as the volume of its business became apparent and the popularity of the route grew, the Wilson Line officials who had looked askance at the project when they were urged to establish it, began preparations for the building of a competing line and their boats are now running.

The officials of the New Castle-Pennsville Ferries, Inc., believe in the spirit of fair play and appeal to the automobile traveling public to patronize its Line. This Company operates the two largest ferry boats on the Delaware River and the schedule herewith shows that the service is planned to accommodate automobilists.

Keep this Boat Schedule and urge your friends to patronize "The Pioneer Line," operating the big boats **"New Castle"** and **"Pennsville"**

New Castle-Pennsville Ferries

BOAT SCHEDULE

EFFECTIVE JUNE 12, 1926
DAYLIGHT SAVING TIME

SUBJECT TO CHANGE WITHOUT NOTICE

—

LEAVE NEW CASTLE (DAILY EXCEPT SATURDAYS)

6.00 A. M.	12.30 P. M.	6.00 P. M.
7.00	1.00	6.30
8.00	1.30	7.00
8.30	2.00	7.30
9.00	2.30	8.00
9.30	3.00	9.00
10.00	3.30	10.00
10.30	4.00	11.00
11.00	4.30	12.00
11.30	5.00	
12.00 M.	5.30	

CHANGE OF SCHEDULE — Between 8 A. M. and 8 P. M. every 20 minutes

LEAVE PENNSVILLE (DAILY EXCEPT SATURDAYS)

6.30 A. M.	12.30 P. M.	6.00 P. M.
7.30	1.00	6.30
8.30	1.30	7.00
9.00	2.00	7.30
9.30	2.30	8.00
10.00	3.00	8.30
10.30	3.30	9.30
11.00	4.00	10.30
11.30	4.30	11.30
12.00 M.	5.00	12.30
	5.30	

ON SATURDAYS, SUNDAYS AND HOLIDAYS

Boats will start at 6 A. M. from each side of the river and continue every 30 minutes until 12.30 A. M. and oftener as traffic demands.

THE SPIRIT OF FAIR PLAY: FERRY SCHEDULE. By 1926, as the copy on the left panel shows, competition from the Wilson Line, "who had looked askance at the project," created the need for trips back and forth every 30 minutes, or "oftener as traffic demands." The front cover has a map with nearby towns. On the back is a reminder: "This line owned and operated by several hundred citizens of Delaware, New Jersey and adjoining States." (Courtesy of Don Reese.)

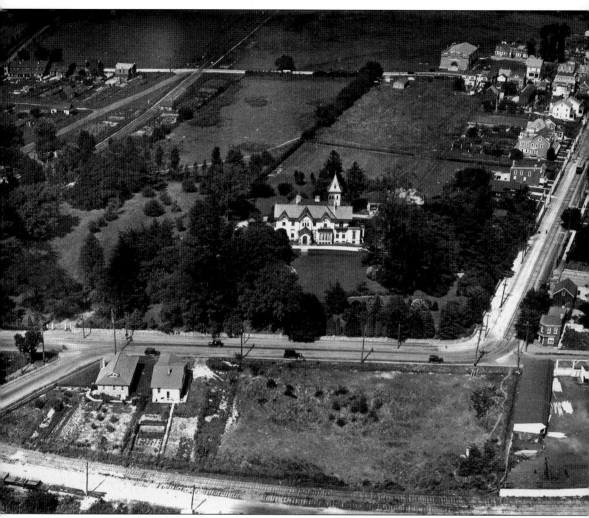

WESTERN EDGE OF TOWN, 1925. This estate, built in the 1850s for Allen V. Lesley and taken over by B. Scranton Deemer in the early 20th century, is surrounded by acres of grass and trees. At the top, perhaps 75 feet to the left of the Armory, a herd of cows grazes in this bucolic scene. In the early 1930s, the fully grown trees in the foreground were removed and transported to P. S. du Pont's nearby estate at Longwood, whose gardens are world-renowned. At the bottom right is the entrance to the J. T. and L. E. Eliason lumberyard, founded in the late 19th century and still active today. (Courtesy of Hagley Museum and Library.)

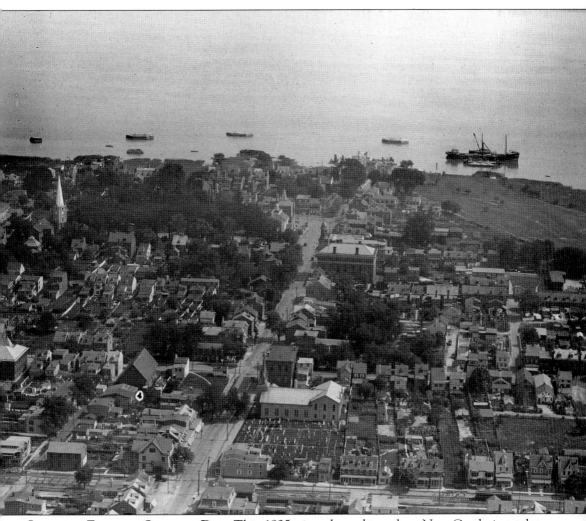

LOOKING EAST ON OPENING DAY. This 1925 view shows how close New Castle is to the Delaware River and its traffic. At center foreground, the Methodist church and its neat rows of graves stand out. Laundry hanging in back yards (center, left) confirms a Labor Day ferry opening—Monday was traditionally wash day—though local newspaper articles put the event on Tuesday, September 2. A trolley on Sixth Street (bottom, right) is stopping to pick up passengers. (Courtesy of Hagley Museum and Library.)

EARLY TECHNOLOGICAL LANDMARK.
Less than a mile below New Castle is
a mostly empty area near the railroad
tracks, formerly used for manufacturing
and now abandoned. This house, from
the period of the ferry opening, holds a
sign that reads: "AMSCO New Castle;
First Electric Heat House; May 20, 1925."

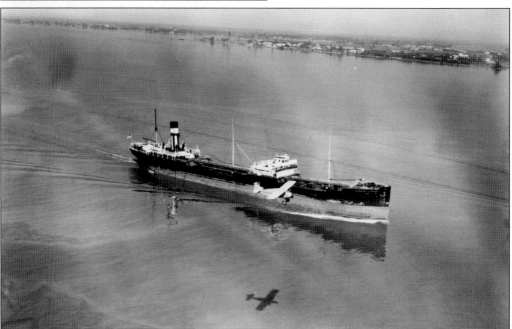

LOW-FLYING PACEMAKER. During the 30-year history of Bellanca aircraft production, New Castle
witnessed many aviation firsts and some spectacular sights. In this view looking east toward
New Jersey, the pilot of the Pacemaker is making an extremely low pass over the tanker *Herbert
L. Pratt*. The bright sun casts a strong shadow of the plane on the surface of river. (Courtesy of
Historical Society of Delaware.)

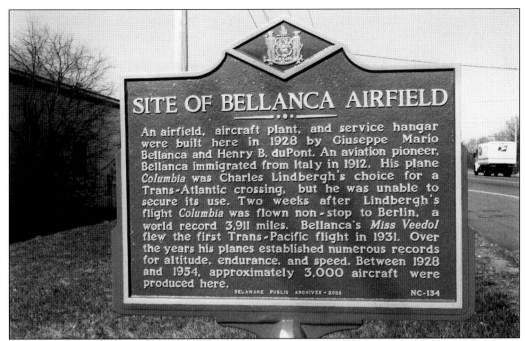

BELLANCA AIRFIELD MARKER. This new marker tells a part of the Bellanca story. Guiseppe Mario Bellanca taught himself to fly and had been through crashes and associations with several bankrupt firms before Henry B. du Pont persuaded him to come to Delaware in the late 1920s. His innovative designs from this era, like the CF monoplane, were cited for their stability and maneuverability.

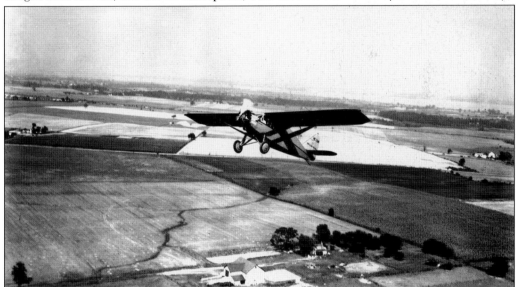

CLIMBING NEAR NEW CASTLE. Bellanca aircraft won many efficiency and endurance trophies and races from the 1920s through the 1940s. George Haldeman flew a Pacemaker, like the one above, to the 1930 men's altitude record of 30,453 feet. The women's record that year (27,418 feet) went to Elinor Smith, also flying a Bellanca. The story has been told in a new book, *Bellanca's Golden Age*, while plans for a museum at the old airfield are progressing. (Courtesy of Historical Society of Delaware.)

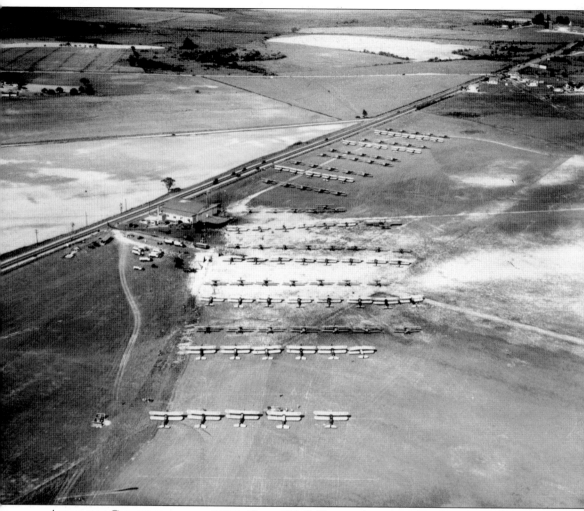

AIRCRAFT CELEBRATION, C. 1930. Over 100 Bellanca planes are lined up near the factory, probably for opening day in October 1928. The original hangar, which burned and was replaced by the still-standing Air Service building, can be seen at left. All the planes carry the Army Air Corps insignia on their wings. At the top, right corner, the first few homes in Washington Park can be seen. (Courtesy of Hagley Museum and Library.)

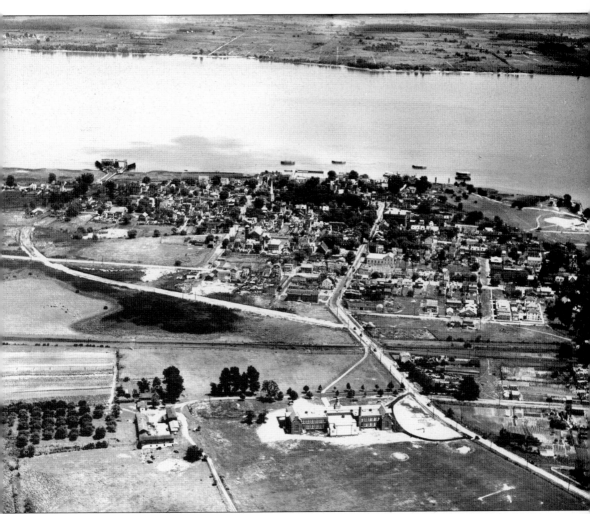

FERRY ENTRANCE, 1932. William Penn High School, which students of all grades attended, stands in the foreground and was opened in 1931. The white band cutting off to the left, then curving toward the river, is the entrance road to the second ferry line, which caused the closing of the original company within five years. The right middle shows Seventh Street cutting through and Deemer Place—housing built for steel workers. (Courtesy of Hagley Museum and Library.)

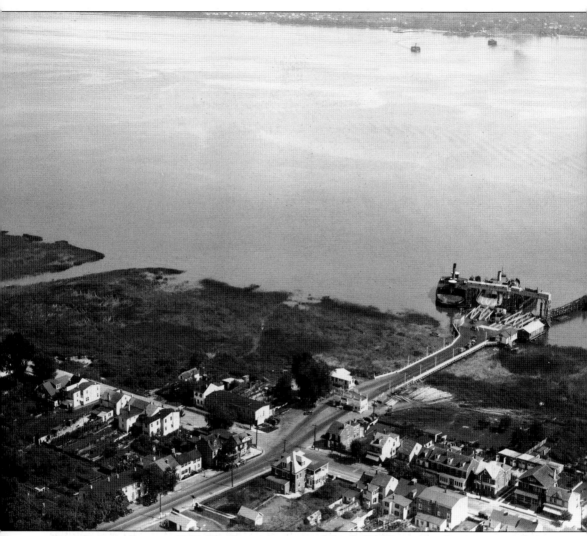

EAST SECOND STREET, 1937. The ferry entrance and the Bull Hill section of town occupy the area near Fort Casimir. Two boats on the New Jersey side, at the top, are on their way to Delaware. At the lower left, a small gas station occupies the area that is now offices of the Municipal Services Commission on Chestnut Street. (Courtesy of Hagley Museum and Library.)

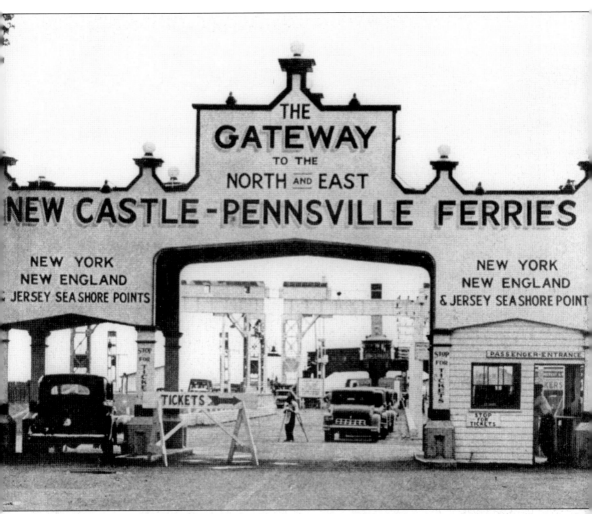

FERRY TICKET AND WAITING AREA, C. 1940. This is a relatively slow day during the Depression, when less than a dozen cars are lined up to board the ferry. In the center, near the last car, stands Mr. Jimmy Cannon, a handicapped resident who sold candy, newspapers, and notions to those waiting in line. His job was eliminated when the Memorial Bridge opened. The ferry's convenience to long-distance travelers is the focus of the grand Gateway entrance. (Author's collection.)

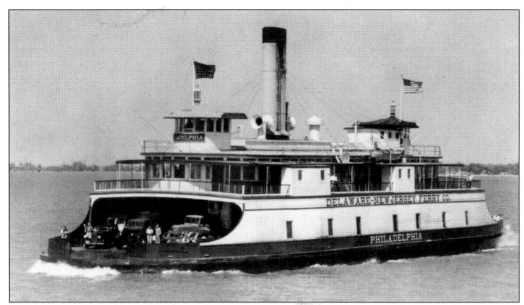

THE *PHILADELPHIA* ARRIVES. This mid-1940s postcard shows cars, trucks, and people on their way to New Castle. The flags indicate both speed and a headwind, while the white foam at the bow is from the forward screw being activated to help her slow down. (Courtesy of Bob Briggs.)

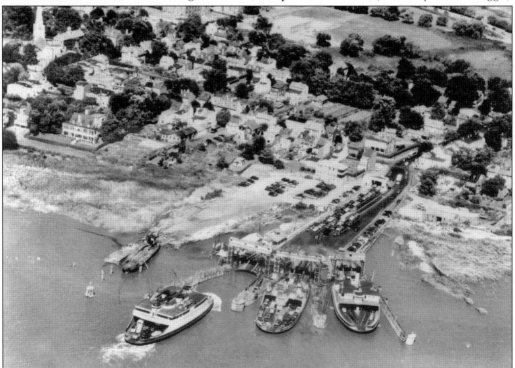

BUSY DAY, LATE 1940s. This crowded area includes three ferryboats and a line of inbound and outbound motorists stretching back onto the Cut-Off at the top right-hand corner—perhaps this is a holiday weekend. All of the infrastructure has now been removed, and the terminal is now grassy parkland.

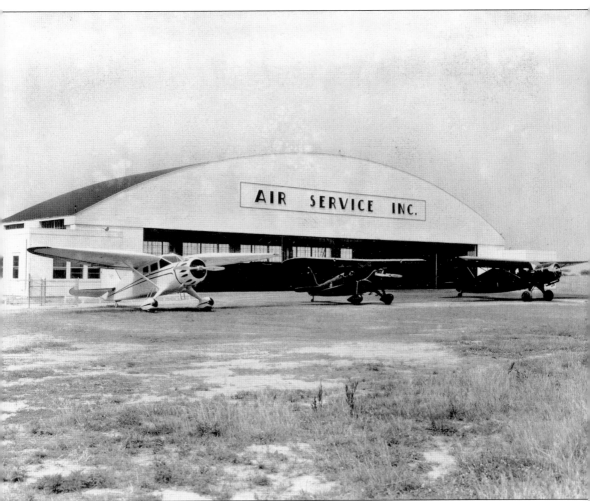

AIR SERVICE HANGAR, 1950s. Started by G. M. Bellanca in 1928, Air Service Incorporated continued in operation until 1960. This building, completed in 1936, replaced the original hangar, which had been destroyed by fire. This building will become an air transportation museum. Nearby, where the Bellanca flying field and manufacturing plant stood, is an extensive office/industrial park. These are not Bellanca planes. (Courtesy of Ms. Sharon Weaver.)

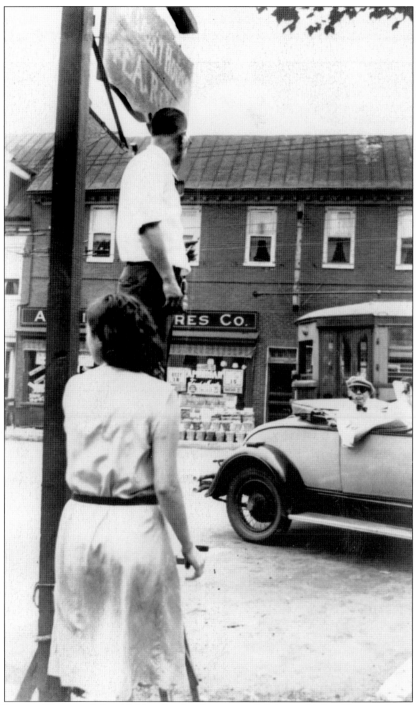

COURT HOUSE SQUARE, MID-1930S. In the foreground, Mr. and Mrs. Horace Deakyne have finished hanging a sign outside the courthouse for their tea room as a friend slows down to chat. Across the street, baskets are lined up outside the American Stores Company, housed in the Gilpin House. Note the passing streetcar behind the convertible. (Courtesy of New Castle Historical Society.)

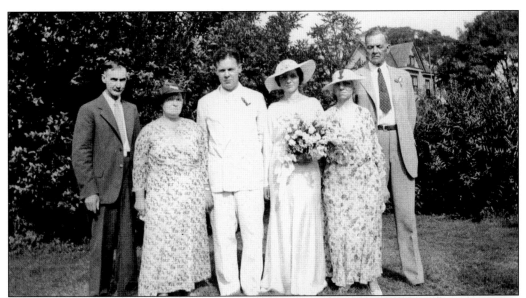

DULING WEDDING AND FAMILY. A wedding party, most with positive expressions, stands near New Castle in 1934 (above). From left to right are Ira Duling, Jeanne Cunningham Duling, James Ralph Duling (groom), Ruth Zimmerman Duling (bride), Clara Filler Zimmerman, and Charles Howard Zimmerman. Grace Duling (at right), daughter of the newlywed couple above, sits in the Megginson farmhouse in 1946. Several rare photos in this book came from her family archives. (Courtesy of Grace D. Hayford.)

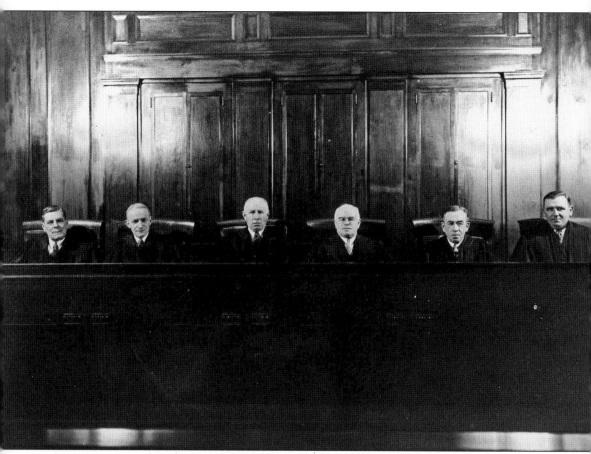

DELAWARE SUPREME COURT, 1940. At the bench, from left to right, are Associate Justice Frank L. Speakman, Associate Justice Richard S. Rodney, Chief Justice Daniel J. Layton, Chancellor N. Watson Harrington, Associate Justice Charles S. Richards, and Associate Justice Charles L. Terry Jr. Judge Richard Rodney was a longtime devotee of state history and local lore. His collected essays covered New Castle geography, Colonial finances, relations with Pennsylvania, education, the Masonic Lodge, romance, wharves on the waterfront, and much more. (Courtesy of Delaware Public Archives, Dover.)

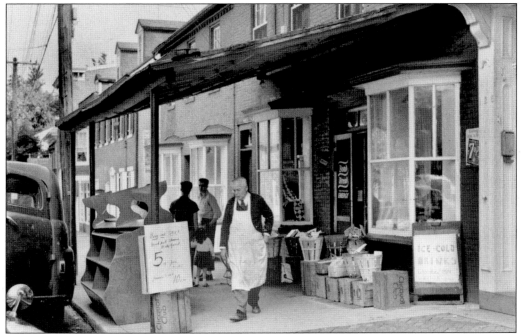

PLATT BROTHERS, "BEST OF GOODS, BEST OF SERVICE." For over 50 years, this landmark general store provided friendly service to the city. Buford Platt and his father, Edward V. Platt Sr., started their business on Delaware Street in 1902. By the 1950s, son Edward Jr. had stuffed the store with sundries, cigarettes, fresh fruit and vegetables in season, and even a shoe store, where youngsters were fitted with their first pair of U.S. Keds (above). Flora Walls Jordan and Edward V. Platt Jr. (below) stand at the counter in the 1950s, although neither ever stood still for a long time. (Courtesy of New Castle Historical Society.)

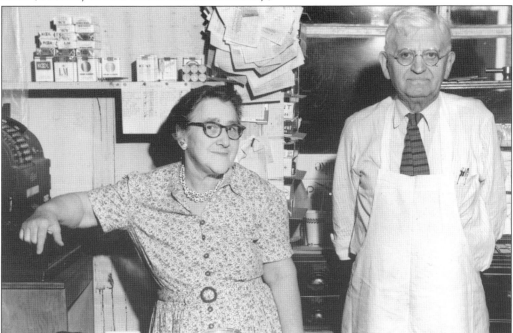

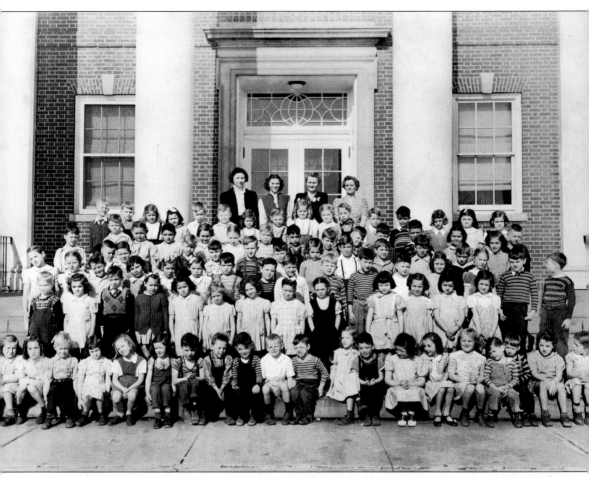

FIRST-GRADE CLASSES, C. 1943. William Penn High School opened for all grades in 1931, in the building above. Specific elementary and middle schools were built in the 1950s and 1960s as the population and suburbs grew following World War II. Pictured left to right are the following: (first row) Norma Schilling, Patricia Bennett, William Timmons, Sadie Evans, Janice Santeski, Norma Cook, Elwin Cox, William Webb, Donald Price, Henry Casey, Francis Downs, Arlene Tirns, Ben Hendrickson, Margaret Riggin, Beverly Enz, Dolores Walker, John Crossely, Robert Taylor, Ruth Hufnal, Sallie Burris; (second row) Maurice Bowman, Sandra Lee Sherman, John Maher, Rose Auten, Kathleen Wright, Elaine Flowers, Alice Jane Flowers, Janice May, Dianna McDaniel, Eleanor Lee MacDowell, Shirley Valente, Sandra Lee Carey, Dorothy Lee Carey, Dorothy Poore, Charles Dean, Charles Thornton, (third row) Jane Walling, Barbara Marvel, Donald Sharpe, Ellen Latham, Karen Jorgensen, Margaret Wolfe, Jack Hoylman, John Rutherford, Martin Shannon, William Wood, Daniel Mickelaw, Charles Newman, Edith Stoddard, Constance Eddy; (fourth row) Steven Soltow, Warren White, William McCracken, Ronald Sherlock, Brice Clough, Frederick Wheeler, Charles Altman, Evelyn Reese, Terry Maxwell, Robert Rees, Donald Moody, Gerald Lane; (fifth row) William Thomas, Alice Donaldson, Elaine Chirco, Jeanette Wallace, Judy Landon, Robert Hultz, Anthony Mavrantonis, William Brown, Kenneth Thomas, Clifford Ellis, Leedom Lefferts, Phyllis Shamholtzer, Barbara Baker, Leo Pierce; (sixth row) George Emerson, Thomas Bradley, Frances Lack, Mildred Fox, James Carney, Reese Foster, Gloria Hager, Arthur Loveless, Dorothy Kinsella, Alice Moore, Thomas Banning, Richard Trevlyn, Robert Kleaver, Lois Gliebenaw, Janice Travers, Sarah Beeson; (seventh row) Mrs. Ruth Duling, Miss Alice Newkirk, Mrs. Elizabeth Stewart, Mrs. Marjorie Montgomery. (Courtesy of Grace D. Hayford.)

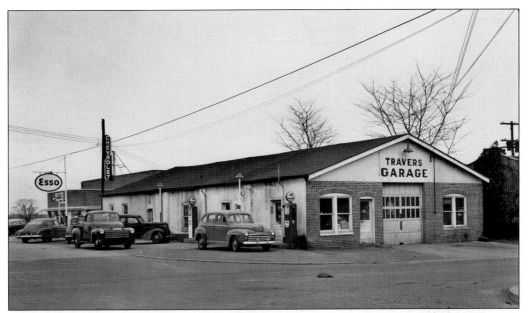

TRAVERS GARAGE, 1951. The Chestnut Street approach to the ferry provided a perfect spot for both auto repairs and gasoline sales. Major N. Travers Sr. came to New Castle in 1914 and repaired machines at a Wilmington tannery. He opened this facility in the 1940s and was offered a Chevrolet franchise in 1941, but he did not receive any vehicles until after the war. The building was demolished in 1990. (Family archives.)

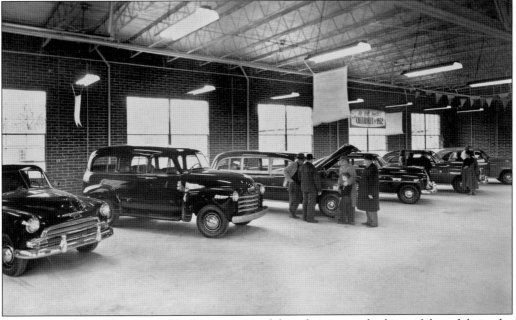

CHEVROLET LINE-UP FOR 1952. Customers and friends inspect the beautiful models in the shop area of Travers Motors. At left, the handsome Suburban predates today's ubiquitous SUVs. Standing near the partially wood-clad station wagon is a group including Major N. Travers Sr., holding his grandson, Major N. Travers III, now retired from the Delaware National Guard. (Family archives.)

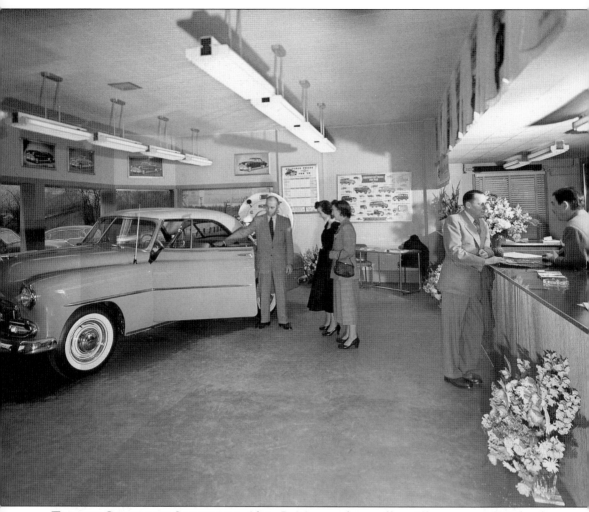

TRAVERS CHEVROLET SHOWROOM. Alvin B. Morean shows off a spiffy, two-tone 1952 hardtop model to Audrey ? (left), then-secretary for the dealership, and Edith M. Travers (right). At the counter, Mr. Charles Smith, then principal of William Penn High School, discusses the latest features with Major N. Travers Jr., who hired a well-known Wilmington photographer to stimulate sales. The auto business changed drastically over the next 20 years, and the new franchise owners moved to the Du Pont Highway in the 1960s, followed by Quillen Brothers Ford dealership. (Family archives.)

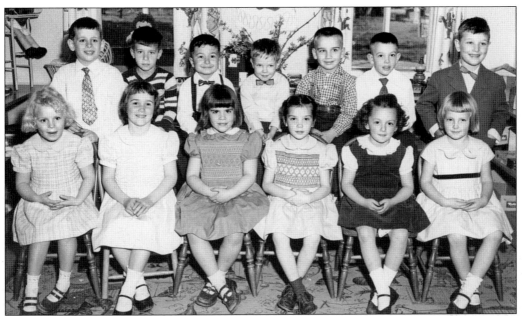

LILLIAN STEWART'S KINDERGARTEN, 1953. Having finished her teaching career, Mrs. Lillian Stewart conducted classes for many years on the first floor of her Fifth Street home. Those included here have names and faces that are fondly remembered. Pictured from left to right are the following: (first row) Jennifer White, Judy Smith, Lili Barney, Mary Jean Gallagher, Kay Linus, and Dorcas Tobin; (second row) Walter Gebhart, Paul Jester, Paul Glawiski, Frank Wright, Fred Kern, Jim Tobin, and Howard Mundell. (Courtesy of Richard Stewart.)

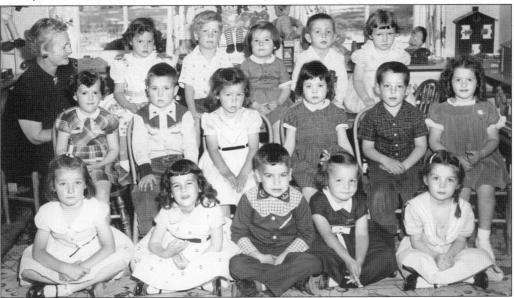

NURSERY, SEPTEMBER 1954. Pictured from left to right are the following: (first row) Linda Mundell, Lois Moore, Lee Moore, Kathy Steele, and Molly Dillon; (second row) Nancy Bush, Bill Stattin, Monica Iverson, Kathy Booth, Jimmie Williamson, and Bonnie Peden; (third row) Lillian Stewart (teacher), Wendy Stine, Billie Barney, Pam Eliason, Joey Foster, and Dawn Walker. (Courtesy of Richard Stewart.)

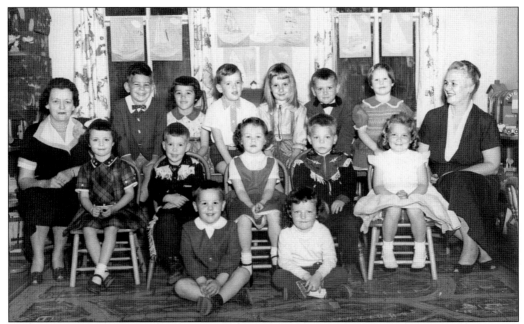

NURSERY, SEPTEMBER 1957. The following are pictured from left to right: (first row) Kenneth Wallace and Becky Proud; (second row) Leigh Dunlap, Jonnie Petze, Melanie Weldin, Peter Toll, and Kathy Davis; (third row) Phyllis Tobin (teacher), Stanley Klein, Sally Eshelman, Dick Appleby, Louise Eliason, Clayton Gebhart, Martha Eddy, and Lillian Stewart (teacher). (Courtesy of Richard Stewart.)

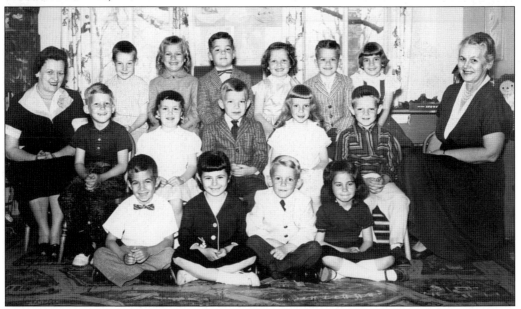

KINDERGARTEN, 1957. The following are pictured from left to right: (first row) Steve DeCherney, Denise DiMundi, Jimmie Lumas, and Karen Jones; (second row) Bobbie Benson, Kaye Dunlap, Johnnie Gunzuylie, Marsh West, and Terrence Steele; (third row) Phyllis Tobin (teacher), Fletcher Sharp, Dolores Pritchard, George Shoop, Francis Lenoir, Albie Miller, Becky Shoupe, and Lillian Stewart (teacher). (Courtesy of Richard Stewart.)

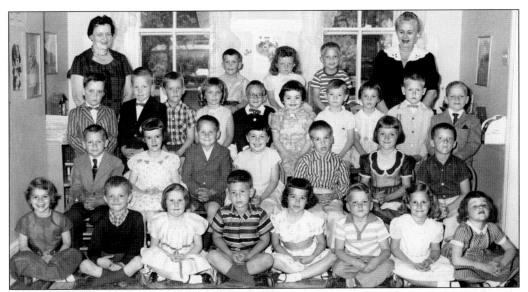

KINDERGARTEN, 1958. Pictured from left to right are the following: (first row) Betsy Nichols, Chris Monigle, Martha Eddy, Stanley Klein, Sally Eshelman, Tommy Bailey, Debbie Stewart, and Melanie Weldin; (second row) Clayton Gebhart, Margaret Johnson, Chandler Cathcart, Kaye Dunlap, Bill Moore, Alice Hughes, and Donald Vantrier; (third row) Fred Gallagher, Randy Thornton, Dick Appleby, Kathy Davis, Corey Barnard, Michele Moore, Rick Hammerer, Joanne White, Robert Short, and Bill McCaffery; (fourth row) Phyllis Tobin (teacher), John Petze, Becky Proud, Peter Toll, and Lillian Stewart (teacher). (Courtesy of Richard Stewart.)

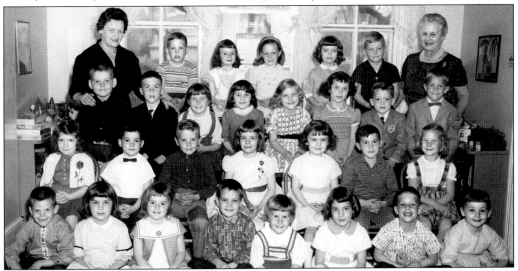

KINDERGARTEN, 1963. America changed after President Kennedy's assassination, but these smiling faces help recall happy days. From left to right are (first row) Keith Duncan, Pam Crock, Deane Dencrell, Charles Cramer, Cynthia White, Carol Powers, Mark Boulden, and Mary Roche; (second row) Lynn Myers, Ethan Fletcher, Joe Bellafore, Lisa Siverney, Kim Wipf, Rick Greene, and Kathy Andruckia; (third row) John Delaney, Mark Buckson, Kay Hewlett, Beverly Wallace, Mary Peden, Joan Roberts, David Reed, and Lee Peplinski; (fourth row) Phyllis Tobin (teacher), Stephen Sparks, Anne Jordan, Paula Wenke, Anne Marie Brett, Skipper Walker, and Lillian Stewart (teacher). (Courtesy of Richard Stewart.)

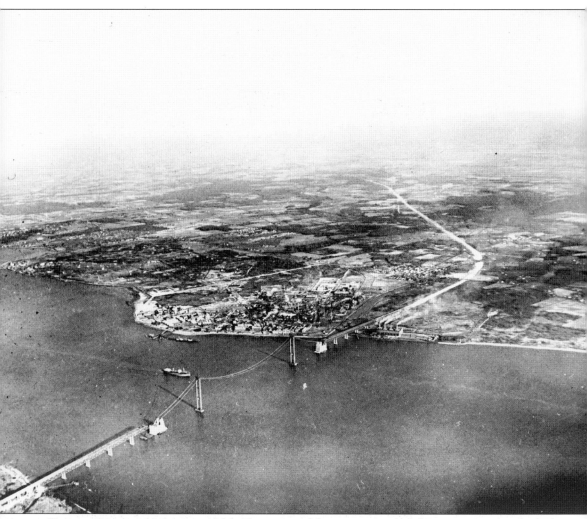

BRIDGE CONSTRUCTION, C. 1950. Two major debates surrounded the construction of a link between New Jersey and Delaware. The oldest concerns the border of Delaware, finally decided in 1934 by the U.S. Supreme Court. Within the 12-mile arc from the New Castle Court House, Delaware extends all the way to the mean low-water mark of New Jersey. Creating a viable financing arrangement of tax-free bonds, plus limited insurance exposure for both states, delayed the project for many years. Looking toward New Jersey, the towers, anchorages, support cables, and approach roads are in place and ready for placement of the bridge deck. (Courtesy of Delaware River and Bay Authority.)

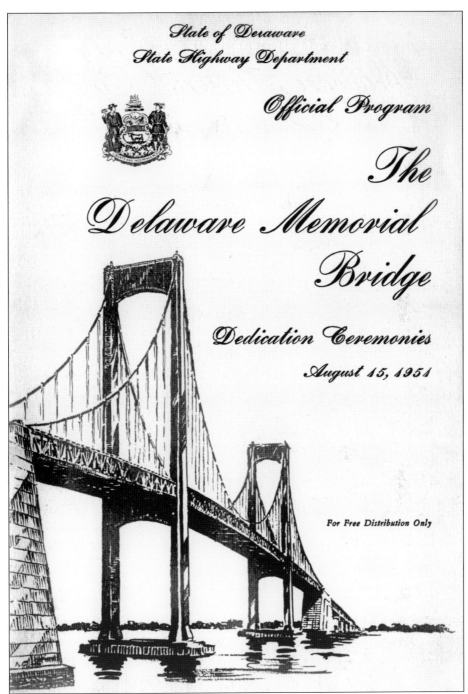

State of Delaware

State Highway Department

Official Program

The

Delaware Memorial

Bridge

Dedication Ceremonies

August 15, 1951

For Free Distribution Only

DEDICATION PROGRAM, AUGUST 15, 1951. With necessary approval from both states and the U.S. Congress in 1947, construction continued until a full-day celebration, including free public bus trips and pedestrian inspection tours, officially opened the bridge. At 11:00 a.m., the dedication ceremony included both governors, representatives of the Veterans of Foreign Wars, and two local recipients of the Congressional Medal of Honor. At 12:01 a.m. on August 16, the bridge opened for business. (Courtesy of Helen Hoagland.)

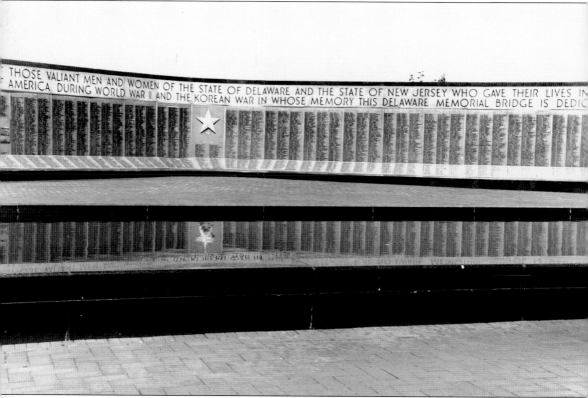

MEMORIAL PLAZA. Most bridge users never see this quiet place of honor, a list of those Delaware and New Jersey residents who perished during World War II, the Korean War, and Vietnam. Originally many people proposed naming the bridge after Franklin D. Roosevelt, who died in 1945, but the Republican governor of Delaware objected. The dignity of the final compromise lives on more than 50 years after completion of the first bridge.

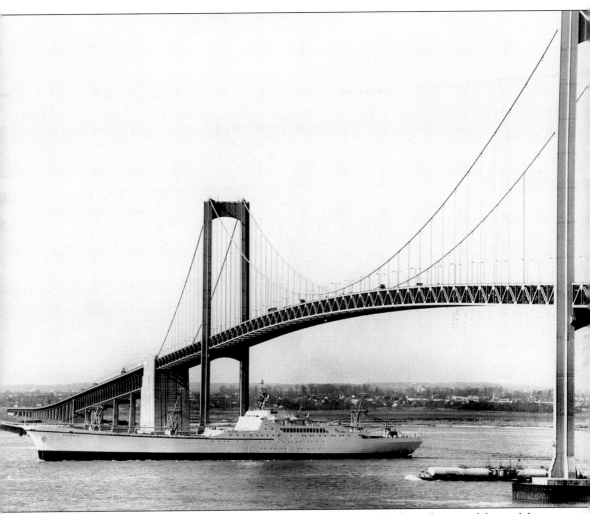

NUCLEAR-POWERED SAVANNAH PASSES BY. Like most suspension bridges, the graceful arc of the 2,150-foot center span beautifully frames any passing ship. Costing close to $44 million, the first Memorial Bridge consumed 291,500 cubic yards of concrete, 12,600 miles of cable, 5,700 tons of reinforcing steel, and 43,000 tons of structural steel. The towers, at 440 feet, are the highest points in Delaware. The flexible cables move under wind loads and changing temperatures, raising the roadway up 4.4 feet, lowering it as much as 6.6 feet, and with horizontal movement of close to 9 feet, all virtually imperceptible to motorists. (Courtesy of Delaware River and Bay Authority.)

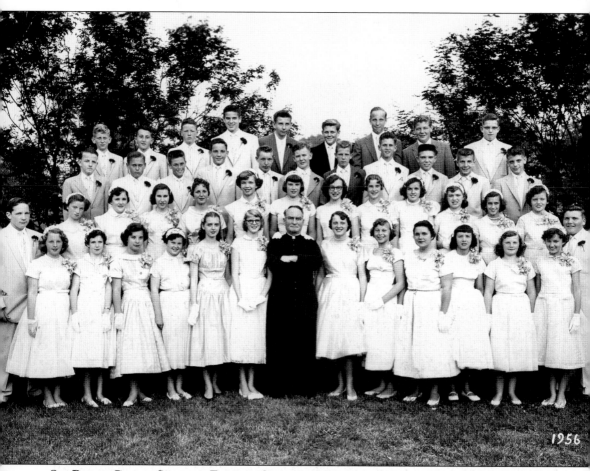

St. Peter Grade School, Eighth Grade, 1956. Men departing for and returning from World War II swelled the population of towns like New Castle. This large class includes, from left to right, (front row) Geraldine Devereaux, Gwendolyn McCaffery, Marian Nasatka, Kathryn Kirby, Martha Sheridan, Elen Irwin, Fr. Andrew J. White, Margaret Furry, Carol Saunders, Ethel Wegrzynowski, Christine Kranichfeld, Robette Papy, and Mary Rae Harrington; (second row) Patrick Ryan, Kathleen Carr, Kathleen Tobin, Nancy Gagnon, Patricia Covelli, Geraldine Moore, Rosemary Peden, Frances Runyon, Jacqueline Steptoe, Patricia Remmel, Janet Moore, Veronica Alexander, Kathleen Schauber, and Herbert Craig; (third row) Robert Ellis, Walter Wierzbycki, Paul Chadick, Michael Ryan, Philip Davis, Richard Keenan, John Morowski, Herman Clark, James Steele, Joseph DeAscanis, and William Weldin; (fourth row) Thomas Cini, Vincent DeSeta, John Kelley, Wayne Allen, James Lowell, Thomas Peden, John Zdeb, Louis Morrell, and Augustine Coccia. Not pictured are Dominic and Philip Caruso. (Courtesy of St. Peter the Apostle.)

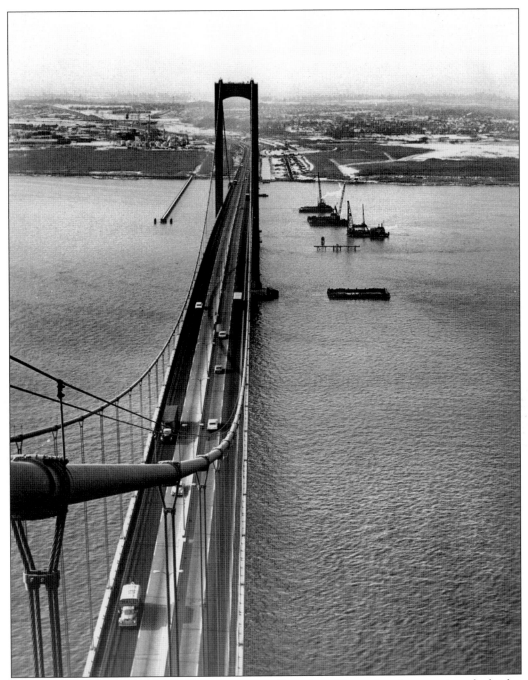

MEMORIAL BRIDGE TWIN SPAN CONSTRUCTION. Less than 18 months after opening, the bridge had counted its four-millionth vehicle. This success led the authority to lower the 75¢ toll to 50¢ for autos, since the bonds were being paid off more rapidly than anticipated. By the early 1960s, when over 11 million vehicles were using the bridge, officials decided to build a twin span, seen in this photo c. 1963. With an identical center span, details of height, anchors, and cost of the new span are quite different. (Courtesy of Delaware River and Bay Authority.)

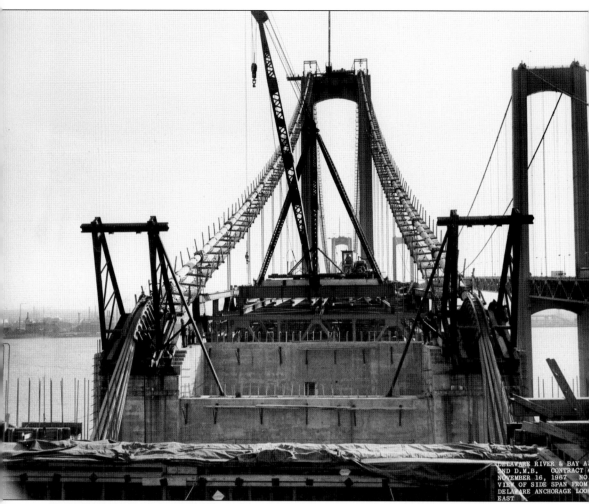

DECK INSTALLATION, 1967. The cables are finished, and pieces of the steel deck superstructure are being installed as traffic passes on the first bridge at right. By 1967, vehicle counts on the bridge exceeded 15 million each year. On July 1, a new, single-day record of 78,640 crossings was set, and summer weekend traffic backups were common. (Courtesy of Delaware River and Bay Authority.)

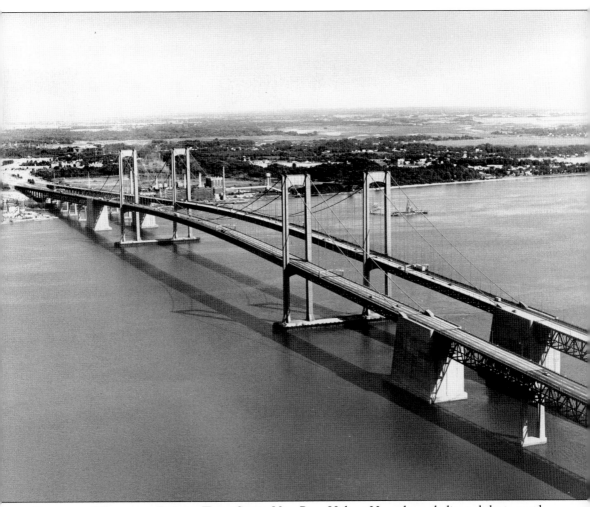

COMPLETE MEMORIAL BRIDGE TWIN SPAN. Vice Pres. Hubert Humphrey dedicated the second span on September 12, 1968. The twin bridges were open only three days. Planned reconstruction of the first bridge began immediately, as well as final details on new interchanges, toll booths, an office building, storage areas under the approaches, and a sophisticated traffic lane control system. Governors from New Jersey and Delaware cut a ribbon on December 29, 1969, to celebrate the one-way traffic movement on each bridge. (Courtesy of Delaware River and Bay Authority.)

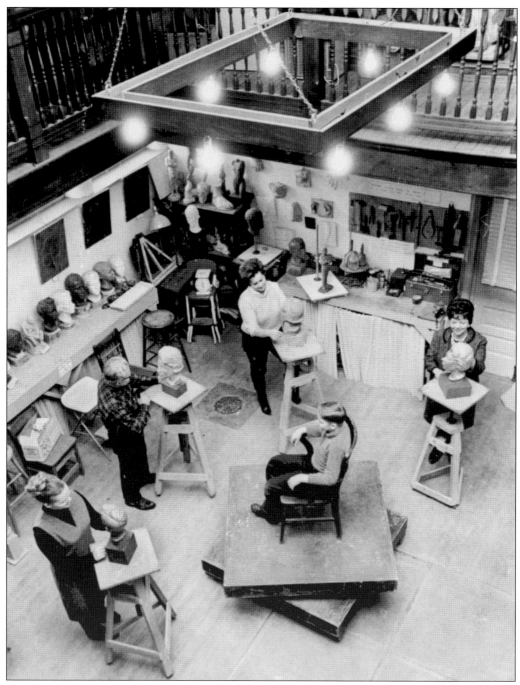

OLD LIBRARY SCULPTURE STUDIO, 1960s. This shot, from the second-story loft area, shows a model and four students, though none of the completed portraits is of the young man seated in the chair. The skylight lets in the best diffused sunlight. While there is no way to identify the others, the third person from the left is Dorothy C. Travers-Davies. The Trustees of the Common have since had the building restored. (Courtesy of New Castle Historical Society.)

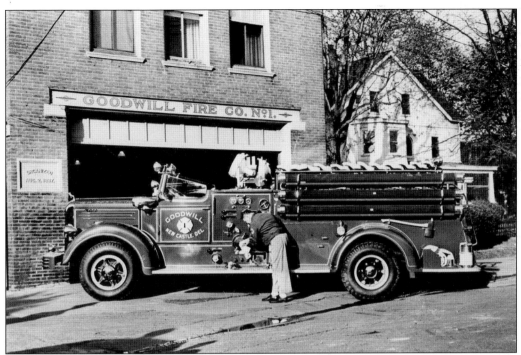

GOOD WILL FIRE COMPANY RELOCATION. Since no land was available to expand the fire hall, erected in 1882, the trustees purchased a large lot about 400 feet away and contracted for a building in the Colonial style. Joe Medora (above), in front of the old building, finishes up cleaning details on the 1950s Mack truck. The aging equipment (below) sits in the door bays of the new facility in 1959. This critical location, near historic buildings, has proven invaluable on many occasions. (Courtesy of Ervin Thatcher.)

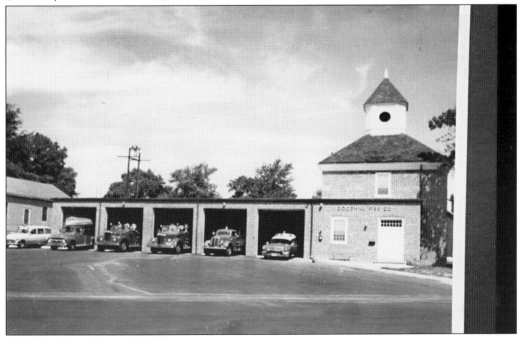

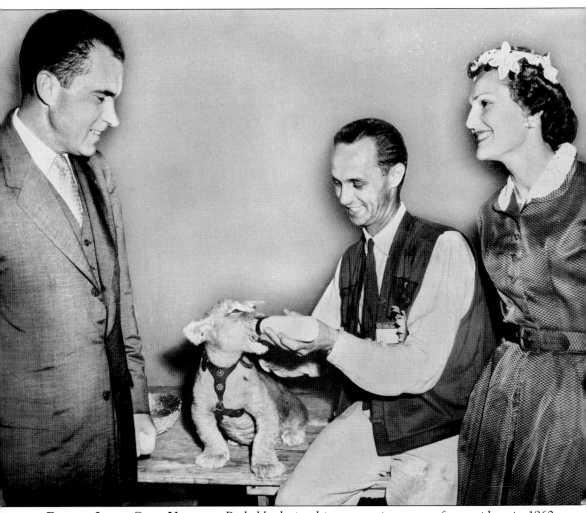

FAMOUS LIONS CLUB VISITORS. Probably during his preparation to run for president in 1960, Vice Pres. Richard Nixon and his wife, Pat, traveled around the country for fund-raising dinners and appearances at dozens of community events. The local club member, seated at center, cannot be exactly identified, nor can the baby lion happily feeding from a bottle. (Courtesy of Grace D. Hayford.)

Four

BEST WALKING TOUR
YOU CAN FIND TODAY

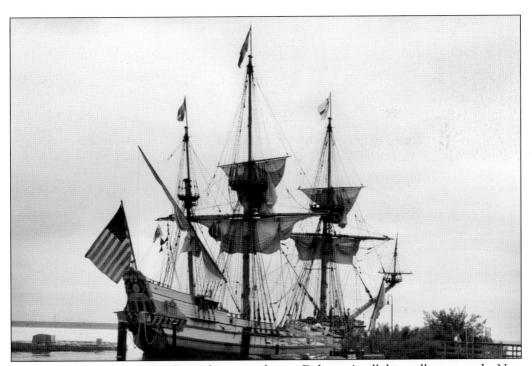

KALMAR NYCKEL ARRIVING. Several times each year, Delaware's tall ship pulls up near the New Castle wharf. Volunteers worked for nearly a decade to create this duplicate of a Swedish vessel that landed at Wilmington in 1638. She made four trans-Atlantic crossings, more than any other ship of the era. Production techniques from the 17th century were used whenever possible. This is surely the best way to arrive in town.

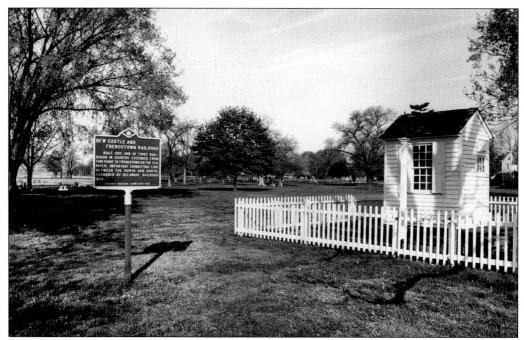

TICKET OFFICE, NEW CASTLE AND FRENCHTOWN RAILROAD. This small building remains from the early days of rail travel. Passengers waited in a simple brick structure nearby, now a private home situated on a corner of Battery Park.

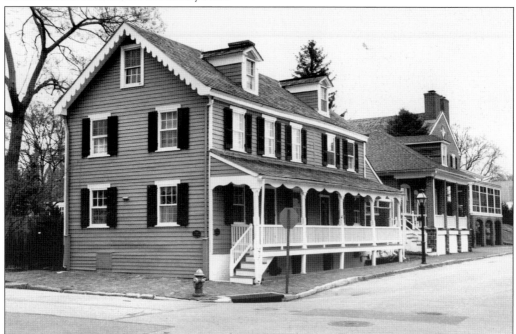

GOVERNOR LOVELACE MANSION, 100 THE STRAND. Dating from the 17th century, the Governor Lovelace Mansion is loaded with legends of prisoners and escapees. Colonial soldiers may have been left to die in a basement dungeon, while Confederate prisoners from nearby Fort Delaware considered this a safe house on their way back to freedom.

RISING SUN TAVERN, HARMONY STREET.
The front section dates from 1796, with
basement kitchen and dumbwaiter. Daniel
Lafferty added a two-room section to the
rear in 1801. The small window visible at
left was used to serve rowdies who were
not welcome inside.

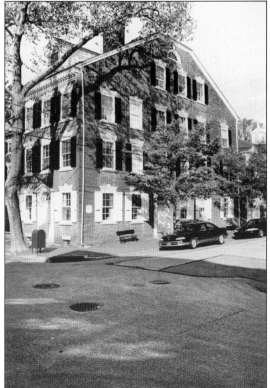

PARISH HOUSE, HARMONY STREET. Little
has changed from the completion of the
structure in 1801. Lunches are served here
for visitors to the annual Day in Old New
Castle, Immanuel Episcopal Church's
fund-raiser, held the third Saturday in
May. Following the February 1980 fire at
the church, services were conducted here
during the Reconstruction period.

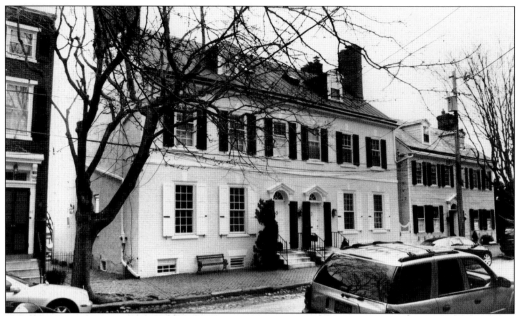

WILLIAM AULL HOUSE AND COOPER HOUSE. At left, 53–55 The Strand dates from 1780. Details include a brick belt course separating the first and second floors and twin arch fanlights over the double entrance. To the right, the Cooper House is one the few wood structures to survive the Great Fire of 1824, though damaged elements were replaced in the 19th and 20th centuries.

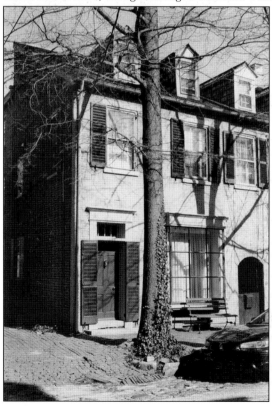

SEXTON HOUSE, 24 THE STRAND. A Dutch-period dwelling here was destroyed in the Great Fire. Delaware patriot Thomas McKean owned the house and rented it to the van Dyke family prior to the American Revolution. The final commercial tenant here was a newspaper printer in the late 19th century.

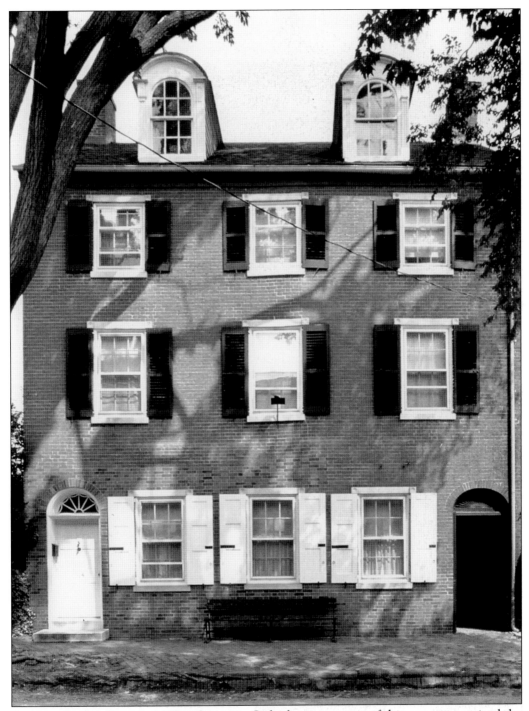

SAMUEL COUPER STORE, 14 THE STRAND. Only the rear section of this property survived the Great Fire. The original ship chandler's shop of the 19th century has been completely changed, though shelves and hooks remain. One of the few remaining smokehouses in town is attached to the back kitchen area. The dark arched doorway at right opens onto a narrow alley leading to the garden behind the house. (Photograph by Gerald Carr.)

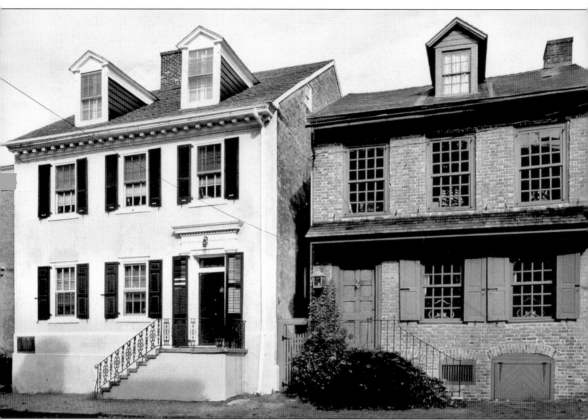

GUNNING BEDFORD AND RICHARD MCWILLIAM HOUSES. At left stands a house built in the mid-18th century by John van Gezel, grandson of a Dutch founder. The 11th governor of Delaware, Gunning Bedford, occupied the house, as did George Read II while his mansion was being built. After Read, the house was operated as a hotel. The stucco has been removed since this photograph was taken. At right, the McWilliam house dates from the early 18th century and displays classic Georgian design characteristics, including corner fireplaces. Both houses indicate that earlier street elevations were probably modified after the Latrobe survey in 1804. (Photograph by Gerald Carr.)

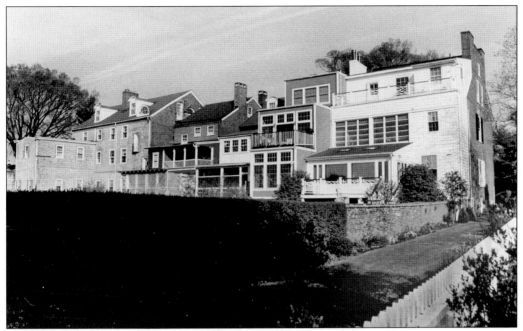

RIVERSIDE VIEW OF THE STRAND. Houses on the Strand face each other, with coveted water and sunrise views available only from the eastern side. The Jefferson House, at left, is the supposed starting point of the Great Fire of 1824. At right, public access to the river is offered by Alexander's Alley, a pleasant, narrow garden path.

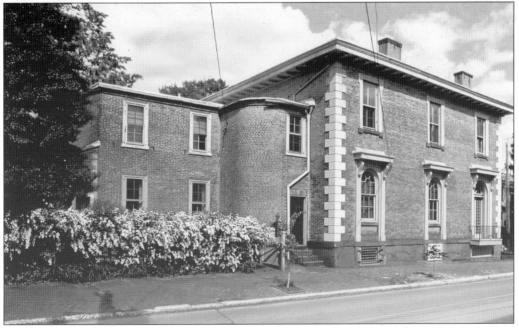

THE OLD FARMER'S BANK. One of the state's primary early banks occupied this site in 1845, when Kensey Johns Jr. was president. The corner quoins are original, but the large supported pediment treatment on the first floor windows, at right, disguise different-sized windows and doors that have since been removed. (Photograph by Gerald Carr.)

THE ROSEMONT HOUSE. This house at 110 Delaware Street still contains a rear wing completed in 1675. Martin Rosemont was a Dutch officer and deacon of the Reformed Church. The front section was completed by 1704 and contains original glass. Note the three-deep belt course between the floors.

JESSOP'S TAVERN, C. 1674. Research by current proprietor Richard Day indicates the early date of construction by Abraham Jessop. This long, narrow town house with two doors lends itself to a pub atmosphere, a tradition upheld for the last 50 years. (Photograph by Gerald Carr.)

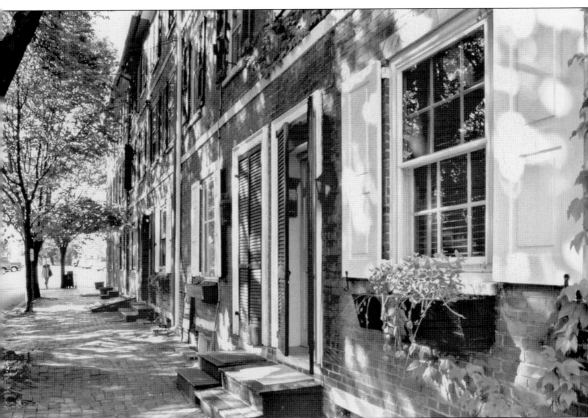

CLOUD'S ROW, 1804. George Read owned this property *c.* 1773. Harlan Cloud purchased the land in July 1803 for $550 as a speculative venture, noting its location near the courthouse, law offices, hotels, and market area. Sales back and forth between Cloud, George Wiley, John and Charles Perry, and others show the up-and-down nature of property values during a five-year period after their completion. Original features in these urban "Bandbox" houses include an enclosed winding staircase, entry into the main living space, and regularly sized fenestration. Some still have the original floors, fireplaces, and mantels. (Photograph by Gerald Carr.)

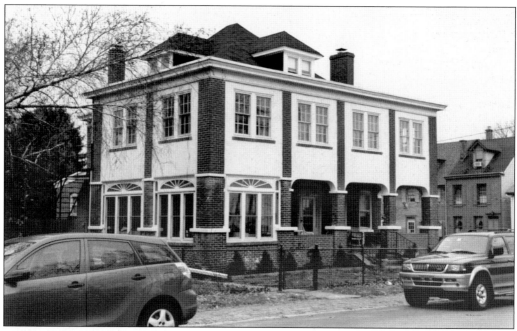

166 East Second Street. This early-20th-century multi-family dwelling has nice views of the river and the site of Fort Casimir. During the period of ferry traffic, cars were lined up on its north side for hours. An early out-building behind the house indicates an earlier structure may have been removed.

Bull Hill House. Ephraim Bull lived in the small house next door and used this as a milk depot. The house dates from the 1820s and was operated as a restaurant while the ferry operated, then as a general store. Renovations in the 1970s converted the building back to residential use. (Photograph by Bob Briggs.)

JEFFERSON ROW. These six town houses, 207–217 East Second Street, were erected in the 19th century to house employees of Elihu Jefferson, who lived on the Strand. Two warehouses stood on the river side at that time. From left to right, each house increases in width. The original layout included only two rooms on the first and second floors, though most have been expanded many times to take advantage of the river views. (Photograph by Bob Briggs.)

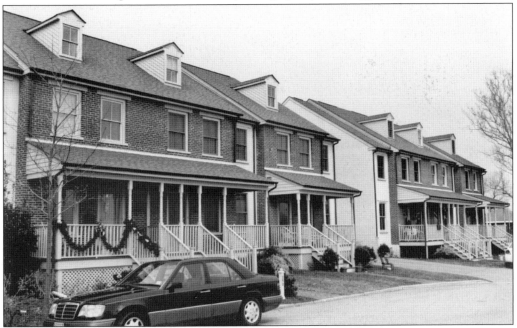

250–262 EAST SECOND STREET. Using design elements similar to other areas of town, these new brick town houses have larger rooms with garages hidden behind them and have pushed real-estate values of once-neglected Bull Hill up tremendously. Little traffic uses this cul-de-sac, though views of river traffic are a strong feature.

154–158 East Second Street. This brick twin house with central alleyway probably dates from the late 19th century, the other homes slightly earlier. Note the progressively smaller window sizes on the upper floors. Residents can see the river between the houses across the street.

144 East Second Street. This side view shows a major renovation that combined two smaller houses, plus a sizable addition with a screened porch and garage, necessary to accommodate a more contemporary lifestyle.

120–124 East Second Street. Dating from the 1820s to the 20th century, the two town houses display Federal features with an interesting brick cornice detail. The house at right features a large, open loft arrangement in the front room with more typical 1960s construction behind.

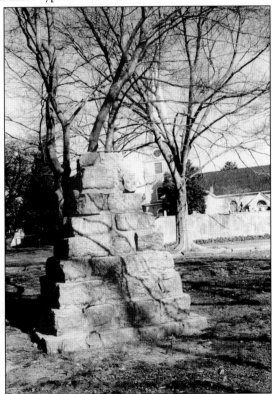

Railroad Monument. The original stone "sleepers" that supported the tracks of the New Castle and Frenchtown Railroad were used to build this rough pyramid. It stands near the Arsenal and Immanuel Church on Market Street, honoring an early engineering and transportation landmark.

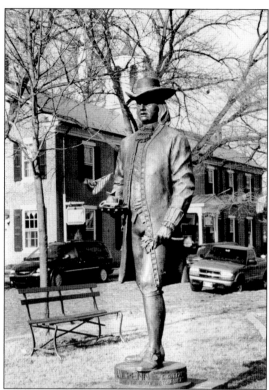

STATUE OF WILLIAM PENN. Standing near the old Market Square, the Quaker founder of Pennsylvania holds water, turf, and the key to the city in one hand, and a twig in the other during the "Livery of Seizin," the act of taking control of his lower three counties. This slightly larger-than-life-size bronze was done by renowned Wilmington sculptor Charles Parks.

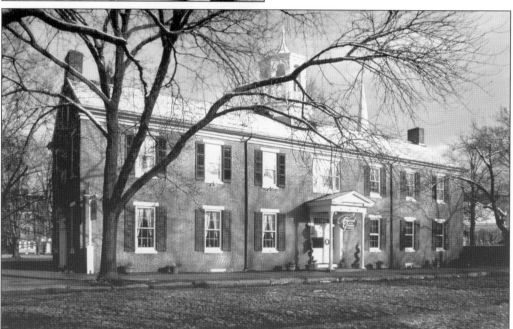

ARSENAL AT OLD NEW CASTLE. The interior décor downstairs reflects the 1809 construction date of the lower story, just before the War of 1812. When a second floor was added and the building was used as a school, a more ornate cupola adorned the building. The windows were added for later uses, since storing ammunition does not necessitate much light.

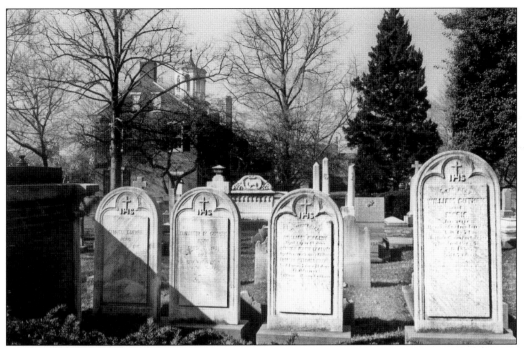

IMMANUEL CHURCH GRAVEYARD. Headstones and larger monuments become rich reminders of our nation's past. A proud family maintained the same design over generations (above), though today's longevity of life was not possible. This area contains markers for early Delaware political and judicial leaders (below) such as Gunning Bedford, Kensey Johns, Col. John Stockton, Thomas Stockton, James Booth, James Booth Jr., and James Rogers.

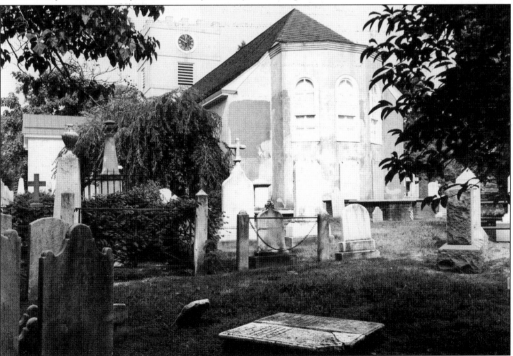

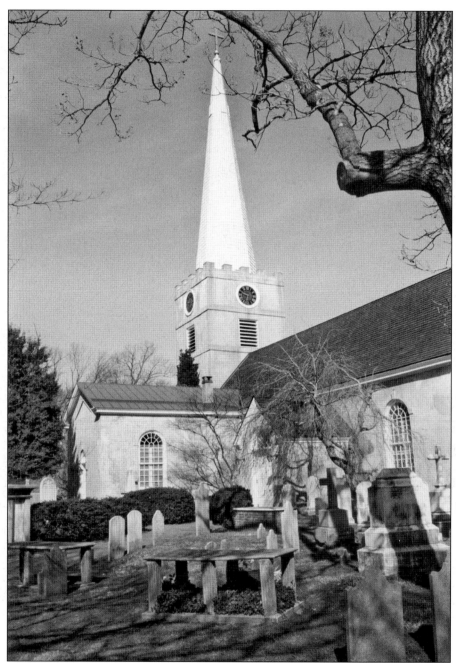

IMMANUEL EPISCOPAL CHURCH, 1703. This building has survived both major renovations and near total destruction. The church originally faced the rising sun, with a small window letting morning light in, a tradition in many denominations. Under the direction of architect William Strickland, the tower and steeple were added in 1820, the altar was moved to the west end, and the transepts were added. At this time, the Trustees of the Common purchased a "fine clock" with four dials, which still chimes the hours today. Many in the community recall February 1, 1980, when embers from a marsh fire and strong wind combined to doom the structure, despite the best efforts of seven fire companies. The bell was later refurbished and reinstalled.

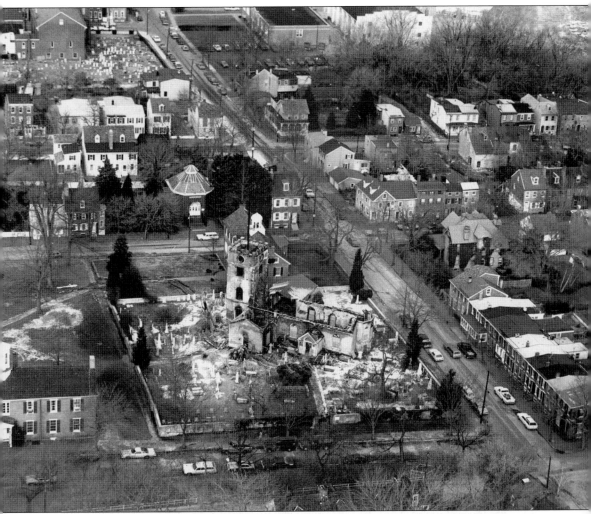

FEBRUARY 1980, AFTER THE FIRE. This recently uncovered aerial view reveals more than just the tragedy surrounding the church building. The compact nature of this portion of the historic district is also evident. The Arsenal stands at left in the foreground, with the Old Library on Third Street behind the ruins. The cupola of the Academy peeks out above the forlorn tower. At the top left are graves near St. Peter the Apostle church, while the entire row of town houses, starting at the lower right on Harmony Street, would have been removed during town restoration proposed in the late-1940s. (Courtesy of Edward J. Camelli.)

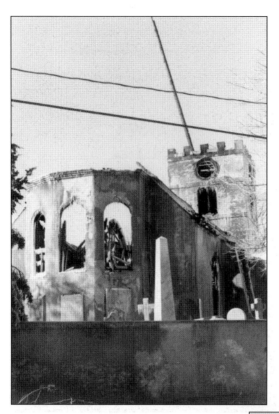

EAST END OF IMMANUEL CHURCH. Gaping holes almost look like staring eyes, while the main tower pole is askew in the background. Members of the Good Will Fire Company struggled for hours to stop the blaze and then saved what they could. They were assisted by the Holloway Terrace, Wilmington Manor, Christiana, Delaware City, and Minquas (Newport) Fire Companies. (Courtesy of Ervin Thatcher.)

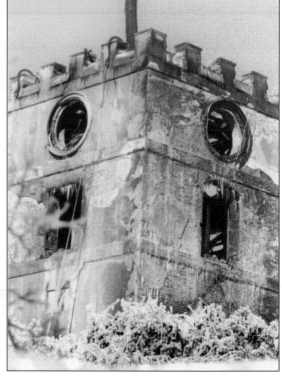

RUINED TOWER. Covered in foam and ice, the clock faces missing, the tower still inspired the congregation to pick up the pieces and begin re-construction immediately. Research under the ruins uncovered details of other, forgotten modifications. The present church maintains the beauty of every original phase in quiet dignity. (Courtesy of Ervin Thatcher.)

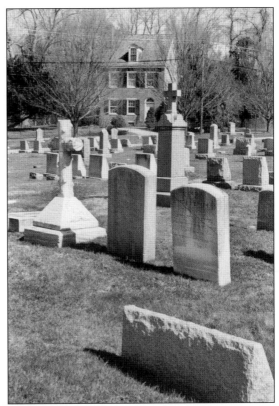

GLEBE HOUSE AND IMMANUEL GRAVEYARD. Since 1719, the rector of Immanuel Episcopal Church has lived in the elegant brick house seen in the background (right), now on the edge of an extended industrial area. Extensive lands surrounded the house, which could be cultivated for the parson's private use or rented out. The graveyard near the church was nearly full by the late 19th century, so subsequent generations have occupied this land about half a mile from town (below).

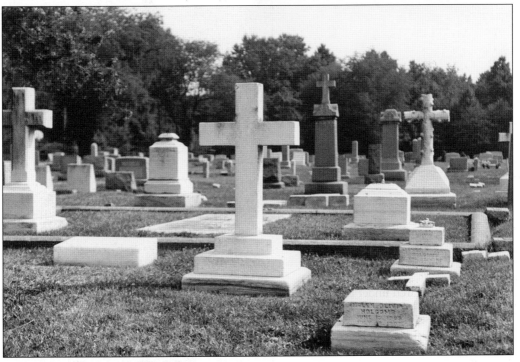

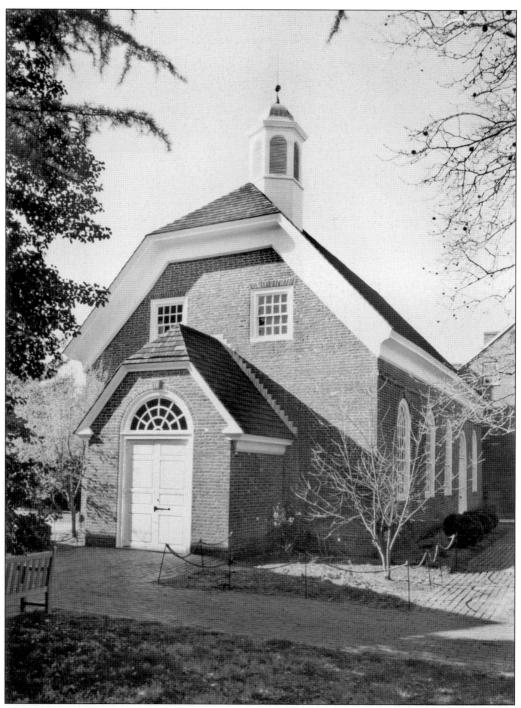

OLD PRESBYTERIAN CHURCH. The Latrobe survey shows the steeple in this location, and the entrance vestibule is a result of Albert Kruse's careful 1950 restoration. The result is one of elegant simplicity, inside and out. While Gothic church architecture often evokes spiritual feelings of wonder and awe, most residents agree with the congregation's decision to tear down the large, "new" brownstone church after World War II.

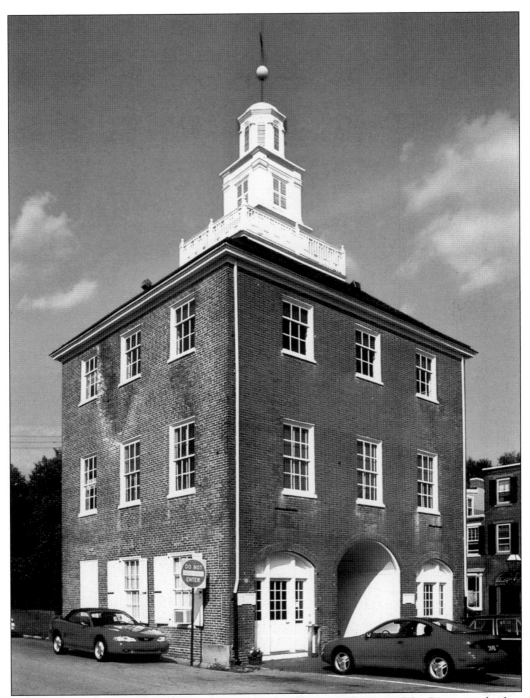

TOWN HALL AND TRUSTEES OFFICE. Recently renovated by the Trustees of the Common, the first floor, at left, is occupied by the town newspaper, which maintains an honor system for payment through the mail slot. The city council meets on the second floor, the open windows allowing passersby during good weather to listen to sometimes heated discussions above. An elegant room on the third floor is used for meetings of the trustees, formerly held in the Richard S. Rodney Room in the public library. (Photograph by Gerald Carr.)

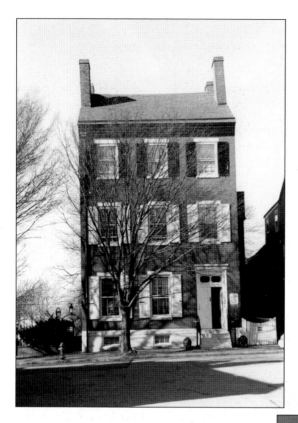

TERRY HOUSE. This 19th-century guesthouse stretches back toward Battery Park, with extensive first- and second-floor porches that overlook the river. Restored as a bed and breakfast, the grand rooms on the first floor welcome visitors.

WILLIAM PENN GUESTHOUSE. Dating from 1682, this house has a clouded history of ownership and residents, including many original Dutch founders. It was once thought that William Penn stayed here on his first night in North America. (Photograph by Gerald Carr.)

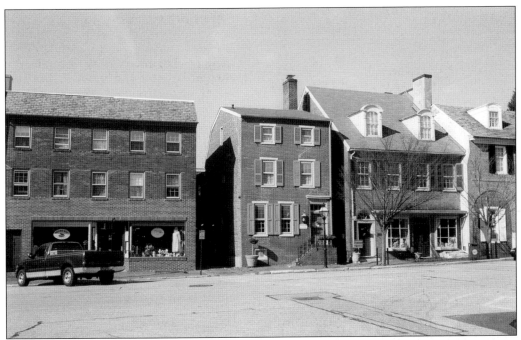

DELAWARE STREET OPPOSITE TOWN HALL. These next two pages illustrate how buildings have been disguised. Set designers for the movie *Beloved* utilized a series of old stores on Court House Square, added period signage, and filled in the street with dirt topped with imitation cobblestones. Some townspeople appeared as "extras" during the market sequence with actor Danny Glover. Note that the concave white gate to right of the Terry House (opposite) has been replaced with a wooden one, topped with a convex curve.

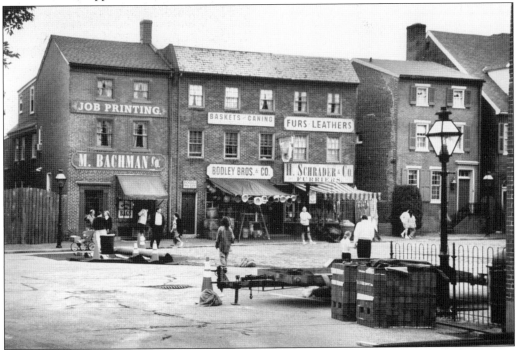

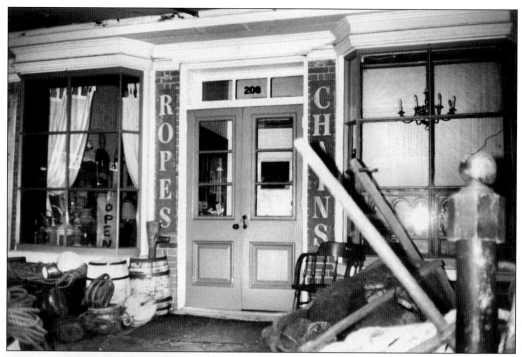

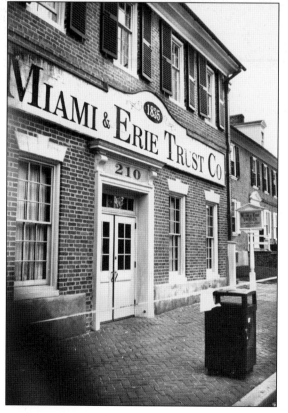

CELLAR GOURMET AND WILMINGTON TRUST COMPANY. The Janvier House (above) has become a dealer in rope, chains, nails, and heavy blocks and tackles. Next door, Gilpin House (at left) is at least in keeping with its present-day use by a major Delaware bank. Window trim for the movie was covered with a layer of "dirt," which was carefully repainted when the crew departed.

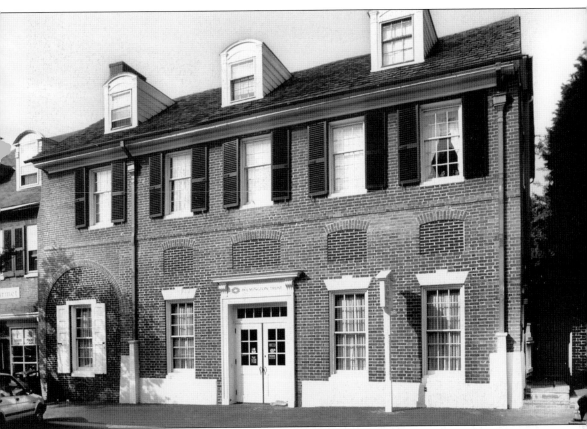

WILMINGTON TRUST, NEW CASTLE BRANCH. The front of the Gilpin House, *c.* 1865, reflects periods of use. At the far left, the decorative arch shows the area where small wagons could pass through to the rear. During the 1970s renovation, workmen discovered, and the bank still displays, an old well. The other arched "openings" on the front echo the small transom windows above old entry doors. An old massive vault was restored and installed. The interior features Colonial-style paneling and colors, state-of-the-art banking technology, and hometown customer service. (Photograph by Gerald Carr.)

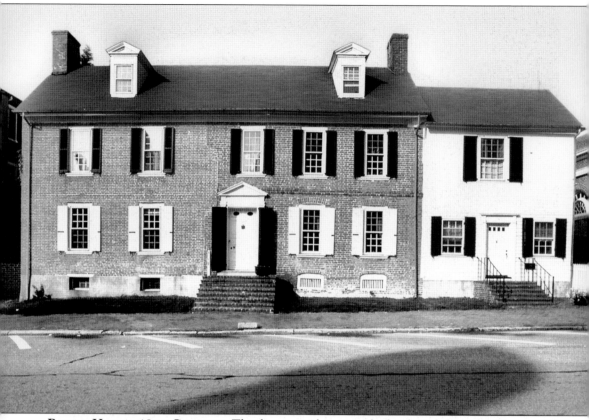

BOOTH HOUSE, 18TH CENTURY. This house sits between the bank and the city offices and is rarely seen without cars parked in front. Note carefully the uneven spacing of the windows on either side of the front entry; the windows on the smaller addition to the right do not match those of either brick section, and the belt course above the first floor is only present to the right of the doorway. The cellar windows on either side of the steps are treated very differently. While the attic dormer windows have also been placed without regard to symmetry, the overall impression is one of quiet architectural elegance. (Photograph by Gerald Carr.)

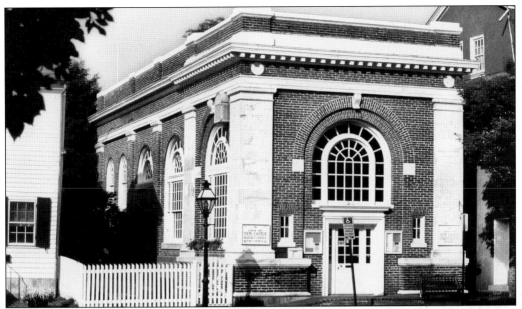

CITY OFFICES: MAYOR AND COUNCIL. The bold arched windows, pronounced brickwork, large-scale dentil molding, and a hint of contrasting white columns signal an important, though narrow, structure. Opened as the New Castle Trust Company offices in 1908, Wilmington Trust Company used this facility until moving into the Gilpin House in 1975. This is the community center: complaints are filed, issues are discussed, and small-town politics is alive. (Photograph by Gerald Carr.)

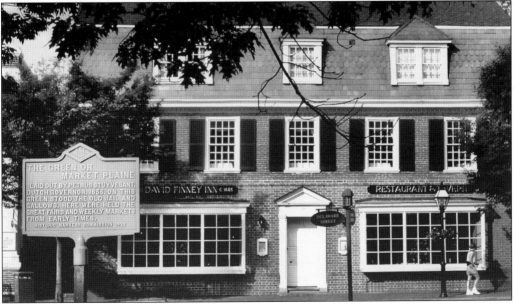

FINNEY INN AND OLD CAPITOL LAW OFFICE. This storied building houses a small law office, echoing activities around the courthouse over two centuries ago. In 1683, the original innkeeper, Revere Vandercolen, used Dutch bricks and leftover ballast, which have been found in excavations. Following his purchase of the property in 1757, David Finney converted the building to a home, used as such by the Booth family until 1903, when it was converted back again as the Hotel Louise. (Photograph by Gerald Carr.)

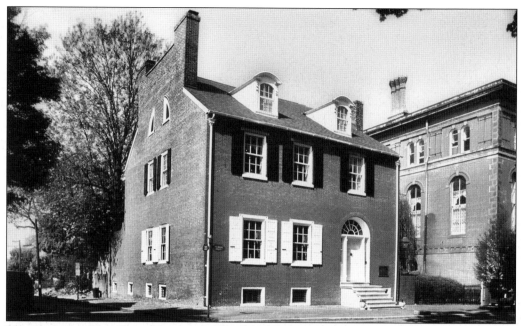

KENSEY JOHNS VAN DYKE HOUSE. At Third and Delaware Streets, this 1820 house sits on land occupied by a tavern in 1798. The windows are offset to the left from the dramatic front entry. The door and the shutters are deeply carved with geometric shapes. White paint covers the solid first-floor shutters, while leftover black paint covers the louvered shutters that allowed better ventilation in the upstairs bedrooms. (Photograph by Gerald Carr.)

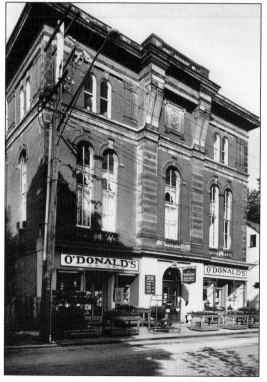

OPERA HOUSE. The Masonic Lodge from 1879 was designed for commercial activities on the first floor. The market, shown here in spring with flats of flowers, has since left the building, and a dramatic paint scheme, perhaps the original motif, has been added. The second and third floors are occupied by a book dealer and publisher. (Photograph by Gerald Carr.)

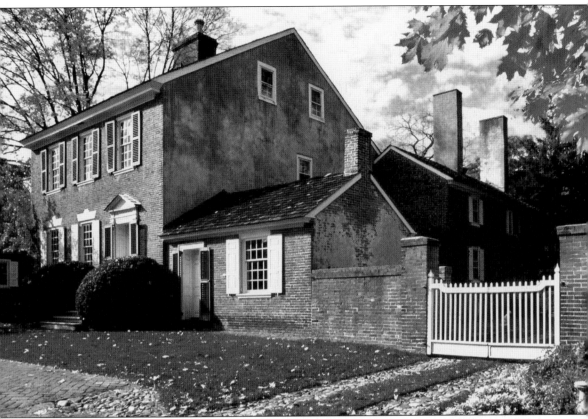

KENSEY JOHNS SR. HOUSE. The rear section probably dates from the late 17th century, and the small addition to the right was a law office. Born in Maryland in 1759, Kensey Johns finished his law studies with George Read and took part in the 1792 state constitutional convention. He was appointed to the State Supreme Court in 1794, rising to chief justice and chancellor before he resigned in 1832. (Photograph by Gerald Carr.)

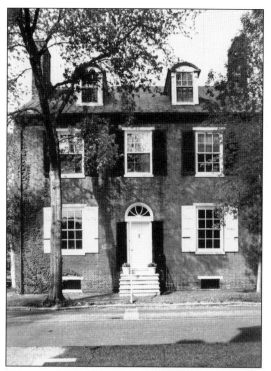

KENSEY JOHNS JR. HOUSE. This handsome house from 1823 is another display of New Castle's once-prominent family lawyers. The younger Johns served briefly in the U.S. House of Representatives, then became chancellor of the Delaware Supreme Court after his father resigned in 1832. The unusual fanlight stands out among others in town. (Photograph by Gerald Carr.)

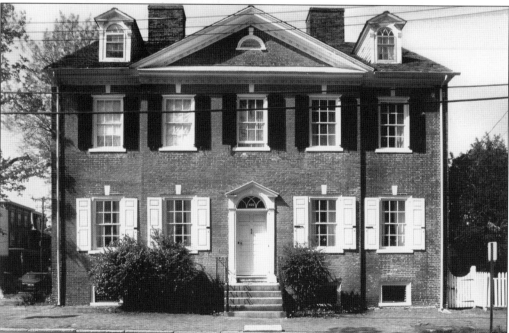

SENATOR VAN DYKE HOUSE. The product of a prolific builder, this handsome 1799 dwelling displays classical symmetry to the street. The pediment, flanked by arched dormer attic windows, is understated. The fanlight over the entrance uses the same curved light cut as in the dormers. On the side, a very narrow flanking addition with porch creates a small courtyard behind the house. (Photograph by Gerald Carr.)

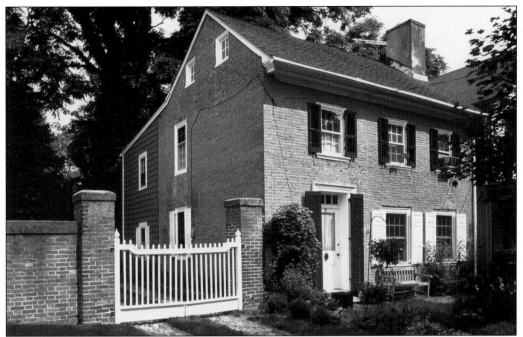

LITTLE YELLOW HOUSE. This *c.* 1789 house was probably built by Kensey Johns Sr., who lived next door. Purchased in 1807 by the widow of a Revolutionary War surgeon, five generations of the Dorsey family have lived here. George Read III and Louisa Dorsey were married at Immanuel Episcopal Church, across the Green, on April 10, 1810. (Photograph by Gerald Carr.)

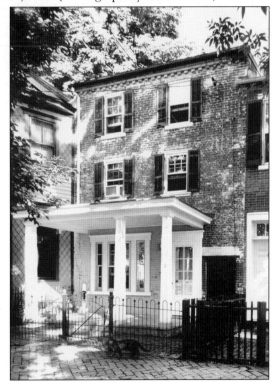

DANIEL MCLONEN HOUSE. This house was completed with two stories in 1769 by one of the original 13 Trustees of the Common. The Rodney and Cooch families have owned the property for 189 years. They added the third floor in the 1830s and the porch around 1900. (Photograph by Gerald Carr.)

113

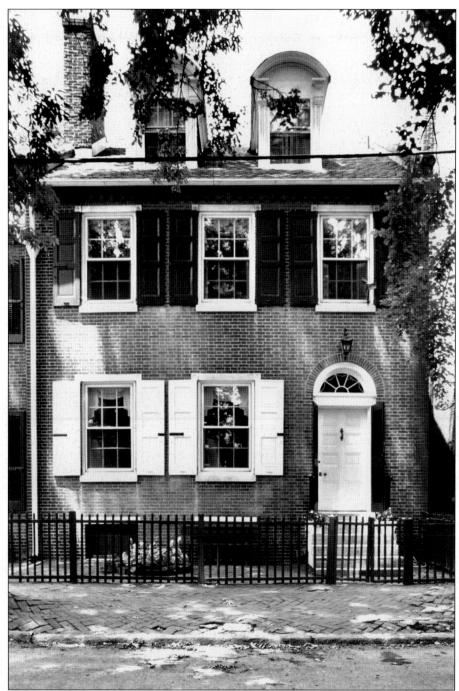

RODNEY HOUSE. George Brydges Rodney built this family house and law office in 1831. George's father, Daniel Rodney of Lewes, was governor of Delaware from 1814 to 1817. Six generations of the family have lived here, and many have practiced law and served on Delaware courts, including the current owner. With a more traditional fanlight over the door, most original details of the house and garden remain today. Note the placement of the dormer windows very close together and slightly offset from center. (Photograph by Gerald Carr.)

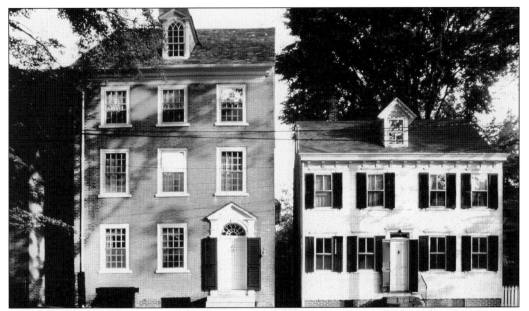

JOHN WILEY HOUSE. Carpenter and builder Peter Crowding completed this house in 1801. Tall at three and a half stories, the elegant 12/12 windows on the first and second floors and the punch-and-gouge work around the doorway are distinctive. In contrast, its neighbor (right) from the mid-19th century is of much smaller scale, with period 2/2 windows and a very narrow, central front entry. (Photograph by Gerald Carr.)

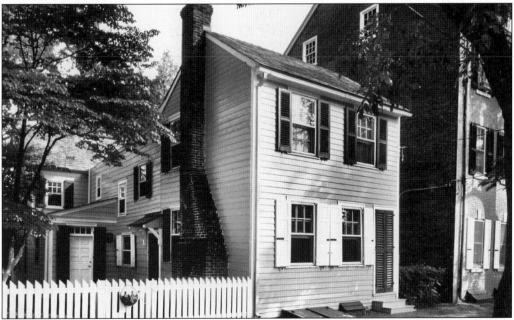

THE LITTLE HOUSE. Small compared to the other houses surrounding the Green, this house's early dining room section dates from the mid-18th century. The front section, a living room with fireplace and second-floor bedroom, was added around 1815. At that time, the house became the property of Anne Alexander Jones, daughter of Archibald Alexander (see next page). (Photograph by Gerald Carr.)

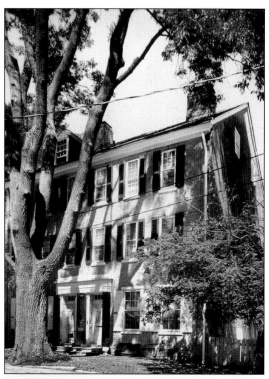

ARCHIBALD ALEXANDER HOUSE, C. 1801. Mr. Alexander was one of the five men who established the boundaries of New Castle and conducted a town survey in 1797. His double house contains sections dating from 1690. The left side is narrower but has a dormer window in the attic. The right side formerly had a covered passage leading to the back garden. (Photograph by Gerald Carr.)

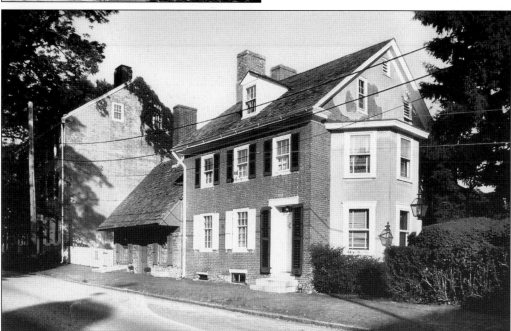

SAMUEL CARPENTER HOUSE. Attached to the Old Dutch House by a common wall, this building has evolved from back to front since 1759. The lot was enlarged in 1770 when two more rooms were added. The front brick section was completed by Mr. Carpenter in about 1825. The 2/2 windows on the stucco-clad bay indicate this was probably added in the late 19th century. (Photograph by Gerald Carr.)

HARMONY HOUSE. Janvier family ancestor Lydia Darragh warned George Washington of British general George Howe's plans to attack the Revolutionaries on December 5, 1777. Margaret Janvier Holcomb and her husband did much of the research and restoration of this house early in the 20th century and deeded it to Immanuel Church, which has used it as their rectory since 1989. (Photograph by Gerald Carr.)

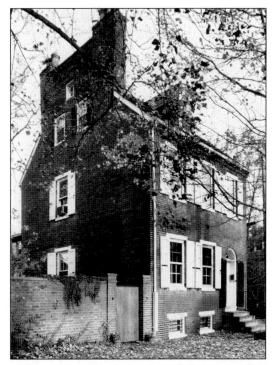

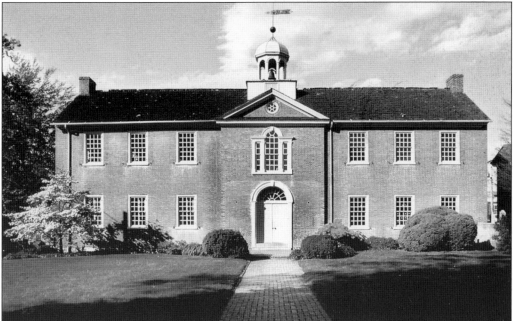

OLD ACADEMY. The land was conveyed to a board of school trustees in 1772, but the building was not started until 1798. It was meant to house the school sessions then being conducted at the Quaker Meetinghouse on Fourth Street, now long gone. Completed in 1811 with funds from the trustees, the broad entry section is capped with a subtle pediment and cupola above. An 1829 ordinance set up the central hallway as a dividing line between election districts. (Photograph by Gerald Carr.)

TOWN HOUSE ON WEST THIRD STREET. Today's builders are forced to use old building styles, since designs must gain approval from the Historic Area Commission. These houses face the river and include brick fronts and door transoms, and they have off-street parking, a rare commodity in New Castle. They were built in the 1990s.

RIDINGS DUPLEX, C. 1895. This late Victorian house has classic elements and sits on a small bluff overlooking Battery Park and river traffic. Small town houses from the early 20th century sit behind it, and a modern, Colonial-style house sits next door to the left.

BOOKER T. WASHINGTON SCHOOL. The du Pont family spearheaded both road and school construction throughout Delaware in the 1920s and 1930s. Designed and built for use by African American children, this building was vacant for years and has now been restored for use by the New Castle Senior Center.

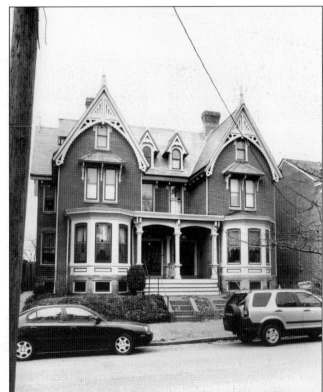

CAPT. AQUILLA HIZAR HOUSE. The house comprises a duplicate of the original 24 West Fourth Street at right, designed by architect Isaac Harding Hobbs and built in the mid-1870s. The high Victorian Gothic-Revival elements include detailed arches with tracery, spires, walkout bay windows, and paneling below the first-floor windows. Appropriately an architect lives here now.

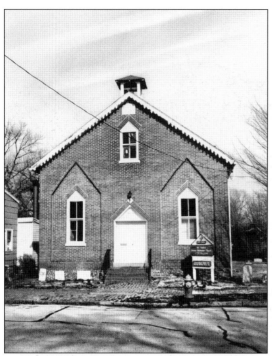

MOUNT SALEM CHURCH. This small and understated church was built for African Americans on the swampy northeast edge of town in 1878. Note the simple scalloping along the roofline, as well as the angle-topped motif on the brick inserts and window and door openings. Some old gravestones of church elders remain at the front and sides. Services are now held elsewhere, since the back wall has partially collapsed.

FIREHOUSE FAIR, 1982. Good Will Fire Company is the site of most trustee, city, state, and national elections. Smoke detector batteries are given out free in the fall. This group is assembled to announce the 1982 winners of a fire prevention essay contest. From left to right onstage are Joseph Toner, Donald Banks, state representative Robert Connor, Ken Sturgis, Mayor Jack Klingmeyer (with daughter Kristin on his lap), unidentified, and chief of police Eugene Petty. (Courtesy of Ervin Thatcher.)

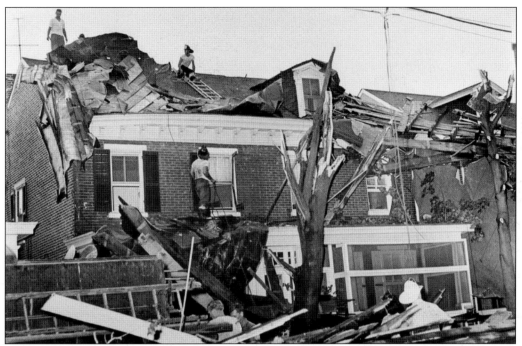

STORM CLEAN-UP. Good Will Fire Company members remove debris after the entire roof of Eliason Lumber Company's storage facility on South Street was lifted off and thrown about 40 feet north along Fifth Street in 1963. Due to the extensive damage from the violent storm, the building was demolished, but these homes were saved. (Courtesy of Ervin Thatcher.)

ELIASON HOUSES. Across the street from the top picture are these elegant Victorian-style residences. At left is the home of James T. Eliason; at right is that of Louis E. Eliason. The bands of polychrome shingles, brightly colored trim lines, and the exuberant use of pediments, bays, and massive porches are all typical of the era, as are the cast-iron fences.

A Mixture of 20th-Century Housing. Farther north on Fifth Street stands a *c.* 1920 twin town house, a rare front-facing hip-roofed cottage, and New Castle's other Craftsman house, built in the late 1920s. The layout and rooms in the town houses are comfortable.

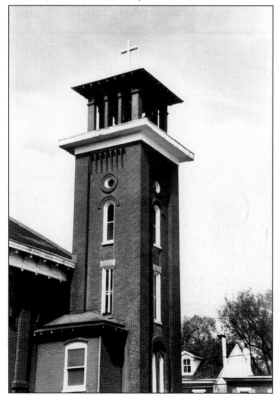

St. Peter the Apostle Bell Tower. An extensive fund-raising drive for the parish's 200th anniversary helped with painting and other refurbishing of architectural details including an extremely handsome set of front doors. This freshly finished tower is a beacon on the northern edge of town.

St. Anthony Parade. Each June, many members of St. Peter's congregation join the parade from the church through the streets of New Castle. Fr. Arthur Fiore (at right center, in black) leads the procession north on Delaware Street, past the new library at right. The float includes a statue draped with wide ribbon, to which donations are attached. At least one Italian band from the region provides music, and a fireworks display caps off the day. (Courtesy of St. Peter the Apostle.)

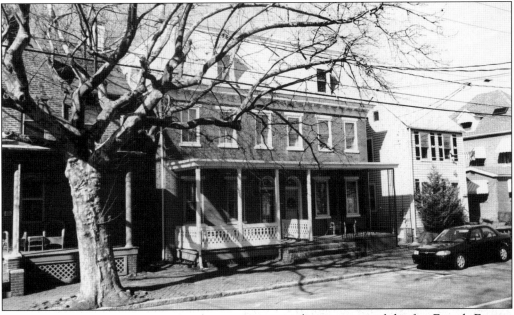

Delaware Street at Sixth. On the way west out of town is one of the few French Empire houses in New Castle. Dating from the late 19th century, it is surrounded by other simple worker houses and new, Colonial-style condominiums across the street.

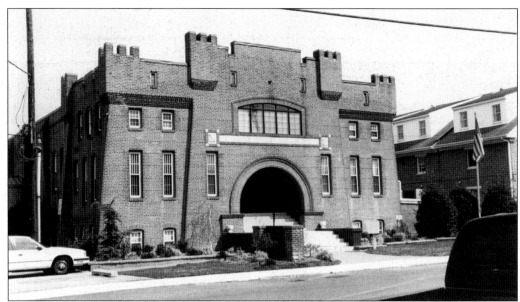

New Castle Armory. This brick "mini-fortress" dates from the early 20th century. Standing at the end of Seventh Street, the strong, slanted sides of the building and a dramatic offset in the bricks around the entrance convey grounded strength. The dark half-circle entry denotes a little mystery. Note the odd shape and sizes of the windows and the pronounced crenellation along the top of the building.

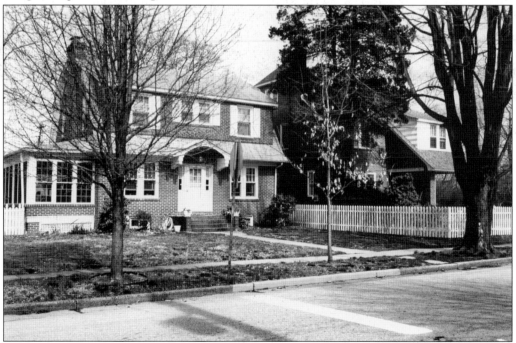

Seventh Street Houses. At the western edge of town, houses date from the mid- to late-20th century, though still utilizing Delaware's ubiquitous brick. Dozens of Italian immigrant families with masonry skills came to New Castle from about 1850. They and their offspring have worked throughout New Castle County but still live in or near town.

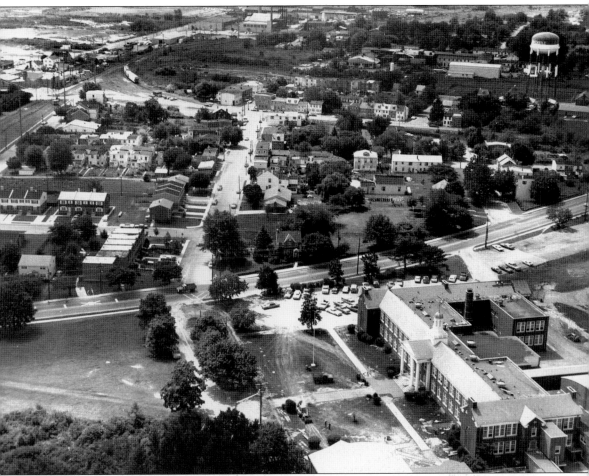

VIEW TOWARD THE SOUTHWEST, 1980. The pilot who photographed the destruction of Immanuel Church in February 1980 continued to make pictures while leaving town. Looking southwest toward Shawtown, William Penn High School stands at the lower right, while the cluster of homes that housed generations of Italians stands west of the railroad tracks, in the center of the image. The water tower at far right is now painted pale green. The cluster of commercial buildings to its immediate left has been razed and is now being replaced with town houses. (Courtesy of Edward J. Camelli.)

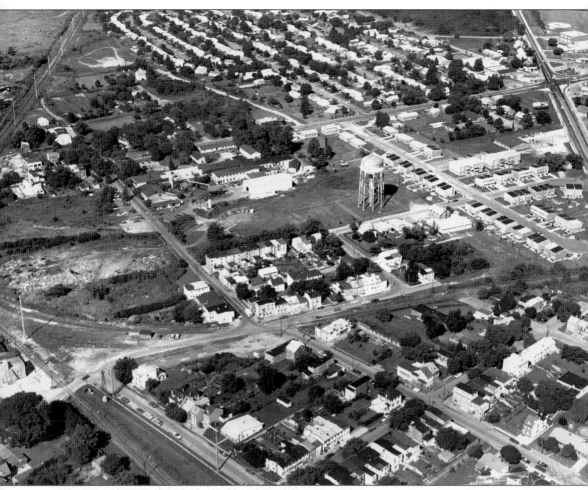

WESTERN SUBURBS, 1980. After a 90-degree turn, Shawtown is now in the foreground at the lower right, and Washington Square and Washington Park can be seen at top, with the water tower now at the right center. In the top right-hand corner stands the complex of First Baptist Church, who tore down their small parish on Fifth Street in the 1950s. (Courtesy of Edward J. Camelli.)

NEW POLICE STATION, 2004. Designed by architects Kise, Straw, and Kolodner with a definite "New Castle" feel, this building displays stylistic motifs such as arch-top openings for windows and doors, strong cornice details, and bricked-in "openings" on the New Castle Avenue side, echoing the adaptive changes made to the adjacent trolley barn over the past several years.

BUTTONWOOD PLANTATION HOUSE. This is the only remnant of Judge James Booth's riverside estate, built in the early 19th century. Like George Read then, and thousands of Delawareans today, gentlemen owned a second home. The 160-acre estate stands on a small promontory and benefits from morning and afternoon breezes, as do visitors to Battery Park. The fifth private owner, William Claghorn, sold the property to Lukens Steel in 1920s. Aware of the building's importance, Zenith Products Company agreed to move the house about 200 feet when they erected their plant here in the late 1980s.

BIBLIOGRAPHY

Abel, Alan, and Drina Welch Abel. *The Golden Age of Aviation Series: Bellanca's Golden Age.* Brawley, CA: Wind Canyon Books, 2004.

Arnold, Heather. *The Tides Led the Town: A Recent History of the Waterfront, New Castle, Delaware.* New Castle, DE: New Castle Historical Society, 1994.

Bailyn, Bernard. *The Ideological Origins of the American Revolution.* Cambridge, MA: The Belknap Press of Harvard University Press, 1967.

Bennett, George Fletcher. *Early Architecture of Delaware.* New York: Bonanza Books, 1932.

Gallant, Kathleen Baker. *The Butcher, The Baker, The Aeroplane Maker: Business in New Castle, Delaware, 1875–1950.* New Castle, DE: New Castle Historical Society, 1995.

Harper, Deborah van Riper. "The Gospel of New Castle: Historic Preservation in a Delaware Town." *Delaware History* Vol. 25, No. 2 (1992): 77–105.

Heite, Louise B., Ph.D, and Edward F. Heite, M.A. *Saving New Amstel, A Proposed City of New Castle Preservation Plan.* Camden, DE: Heite Consulting, 1989.

Higgins, Anthony, ed. *New Castle on the Delaware.* New Castle, DE: New Castle Historical Society, 1973.

McAlester, Virginia, and Lee McAlester. *A Field Guide to American Houses.* New York: Alfred A. Knopf, 1995.

Rodney, Richard Seymour. *Collected Essays.* Wilmington, DE: The Society of Colonial Wars in the State of Delaware, 1975.

Tyler, David Budlong. *The Bay and River Delaware, A Pictorial History.* Cambridge, MD: Cornell Maritime Press, 1955.

Wheeler, Arthur Jackson. *Buttonwood Plantation Manor House.* Proposal to save the building, 1986.

Williams, William H. *The Garden of American Methodism: The Delmarva Peninsula 1769–1820.* Wilmington, DE: Scholarly Resources, 1984.